Jean Haines COLOUR & LIGHT IN WATERCOLOUR

NEW EDITION

Staffordshire Library and Information ServicesPlease return or renew by the last date shown

-		
BURTON LIBRARY, BURTON-ON-TRENT. 1	HIGHST.	
TOTAL ON THE INCINE.	Indu: 25655	
1 3 MAR 2019		
		1

If not required by other readers, this item may be renewed in person, by post or telephone, online or by email. To renew, either the book or ticket are required.

24 Hour Renewal Line 0845 33 00 740

Staffordshire

3 8014 11009 4023

Jean Haines COLOUR & LIGHT IN WATERCOLOUR

NEW EDITION

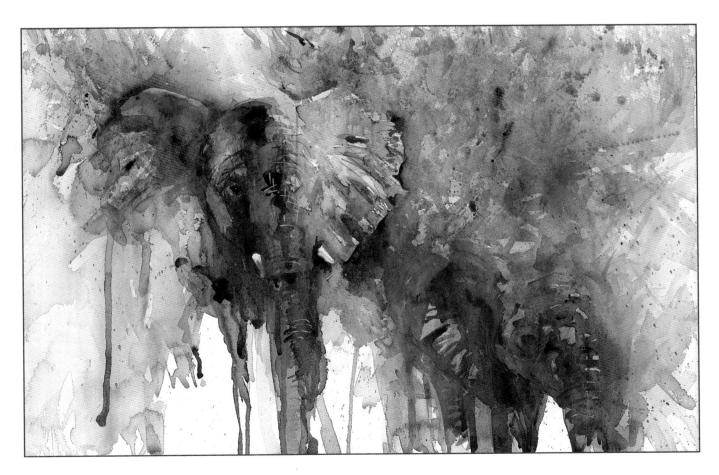

Acknowledgements

The Society For All Artists (SAA) recognised my passion for watercolour, introduced me to writing articles for Paint magazine and from here the feedback from SAA members urged me to write and fulfil my ambition to become an author.

Chandy Rogers, John Hope Hawkins and Richard Hope Hawkins of SAA all led me to a wonderful opportunity to write my first book. I know they all play a part in many artists' careers. To have this opportunity to say thank you is a privilege.

Search Press as a publisher made my dream come true. The whole team at this wonderful company have to be seen to be believed. I owe very special gratitude to Roz Dace, whose faith in me from the very beginning of this project was incredible.

Katie French, my editor, has a wonderful personality and nature, understanding how I wanted my book to emerge and at times almost feeling as if she knew me inside out.

Amazing photographers, Roddy Paine and Gavin Sawyer – thank you for making my photography shoots memorable, fun and a fantastic experience.

To every artist and student who encouraged me to write my first book in watercolour I owe this book. Your enthusiasm led me to this stage in my art career and I cannot thank you enough for all your enthusiasm and interest in my work. I have taken every comment on board and hope you enjoy what you have wished me to do for some time now. This book is for you.

Finally I owe a huge thank you to my wonderful husband John who not only always encourages me to follow my dreams but has a hand in every one that has come true, and allows me the time and space to complete my books.

Thank you.

Jean Haines

First published in 2010

Search Press Limited Wellwood, North Farm Road, Tunbridge Wells, Kent TN2 3DR

New edition published 2015

Text and art copyright © Jean Haines 2015

www.jeanhaines.com watercolourswithlife.blogspot.co.uk

Photographs by Roddy Paine Photographic Studio

Photographs and design copyright © Search Press Ltd 2015

All rights reserved. No part of this book, text, photographs or illustrations may be reproduced or transmitted in any form or by any means by print, photoprint, microfilm, microfiche, photocopier, internet or in any way known or as yet unknown, or stored in a retrieval system, without written permission obtained beforehand from Search Press.

Paperback ISBN: 978-1-78221-261-4 Hardback ISBN: 978-1-78221-403-8

The Publishers and author can accept no responsibility for any consequences arising from the information, advice or instructions given in this publication.

Printed in China.

COVER
Winning Colours
64 x 40cm (251/4 x 153/4in)

PAGE 1

Rocky Robin
24 x 36cm (9½ x 14¼in)

PAGE 3
Out of Africa
71 x 61cm (28 x 24in)

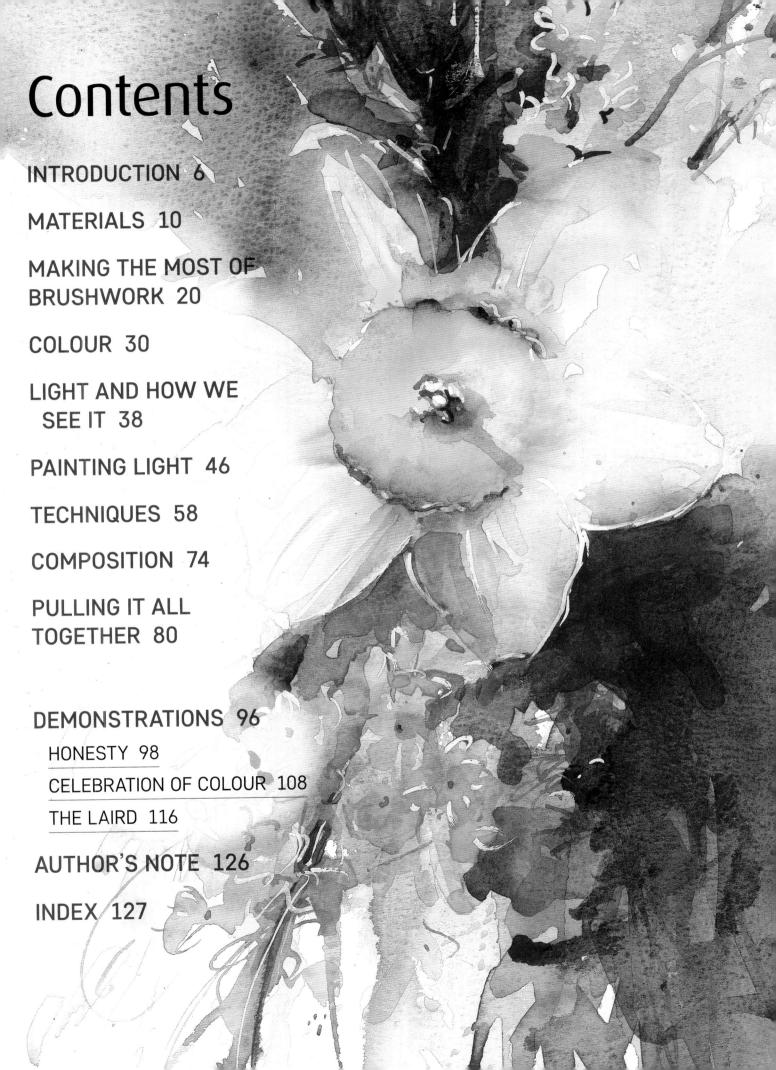

Introduction

I first saw a pure violet-coloured shadow when I was living in Dubai. I remember looking in awe as the sunlight hit one side of a dishdash, the white robes worn by Arab men, leaving warm shades of gold splattered amongst the violet shadow cast on the ground at the market. Everywhere I turned sunlight created patterns of colour all around me and I was fascinated.

For years I had looked at watercolour paintings depicting scenes where violet or other colours were used to depict shadows, but I had never truly noticed colour so strongly as at that moment in time. It was as though a veil had been removed from my eyes and all of a sudden different colours came into play as I looked at other subjects I had often painted. I saw green in faces for the very first time and a whole host of colours other than blue in a sky.

Suddenly, picking up a paintbrush became an addiction as I constantly tried to capture the play of light in each scene that unfolded before my eyes: sunflowers in France, fish markets in Hong Kong, carnival masks in Venice, camels and mosques in Dubai. I have travelled and lived in many countries since 1989, and have continually met wonderful artists who have shared their knowledge with me and students who have asked me questions regarding light and the best way to paint it. My reply is always filled with enthusiasm and excitement for the fact that they can see light in a scene in the first place. This, to me, was the hardest part in my watercolour journey – actually seeing colour and light.

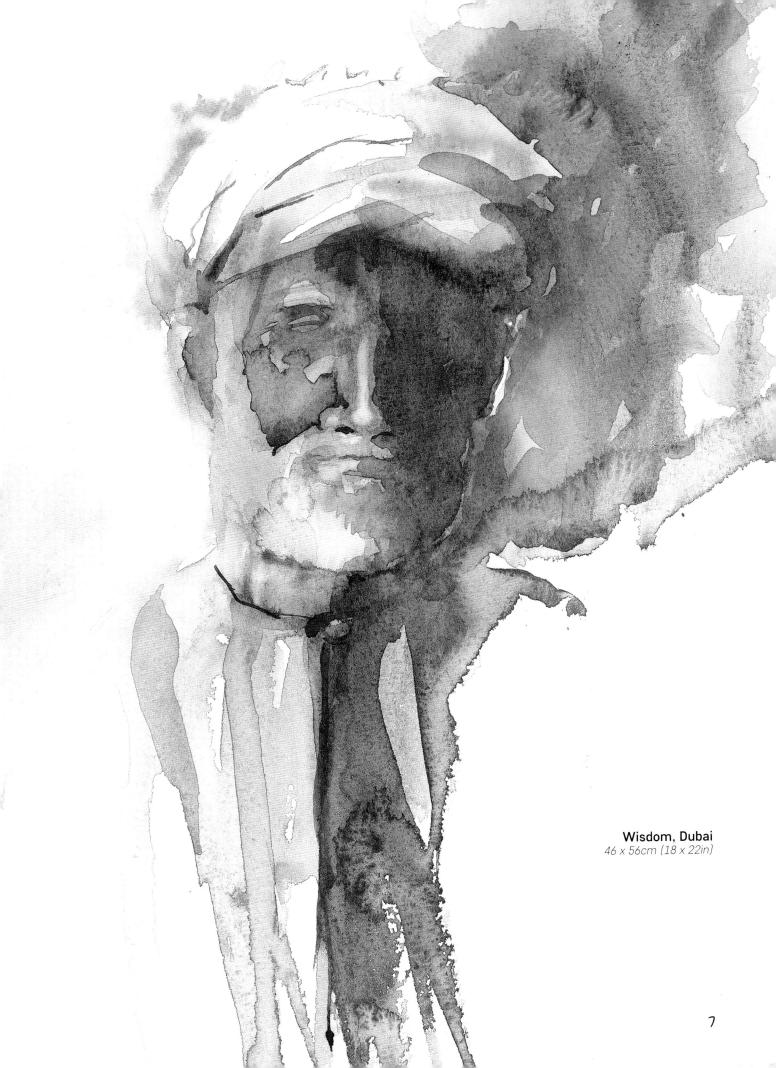

I hope this book on how to paint colour and light in watercolour takes you to a stage in your art journey where you too start to see violet shadows and colour in a way that leads you into a whole new world as an artist. And I hope my addiction to light and colour becomes a passion for you as much as it is for me.

THE NEW EDITION

I remember the excitement at being offered the opportunity to write the first edition of this book. It was my first book, and I was thrilled. Up until that time, writing and sharing my love for watercolour had always been a dream of mine that seemed completely out of reach. So when I was asked to write a book about colour and light in watercolour, I leapt at the chance and loved every minute of the experience.

Since then I have gone on to write two further books: Atmospheric Watercolours and Jean Haines' World of Watercolour. I have grown in my art career and learned a great deal from travelling and teaching watercolour workshops all over the world – so much so that my publisher suggested I revisit my first book to add more material and breathe new life into it, injecting it with even more enthusiasm and passion.

So here I am: adding demonstrations that initially there was no room for, and paintings that show how I have evolved as an artist. It has been a true privilege to work through each chapter again, thinking of you, my readers, and hoping you will enjoy this larger, improved version.

I often think that if I could start my life again, would I still want to be an artist? The answer is a resounding 'yes'. Revisiting *How to Paint Colour and Light in Watercolour* is a return to the past – a magical reunion. This book will always be special to me as it is the first I ever wrote. So to give it far more of my heart seems very fitting. Have fun reading it, and I hope you grow to love painting as much as I do!

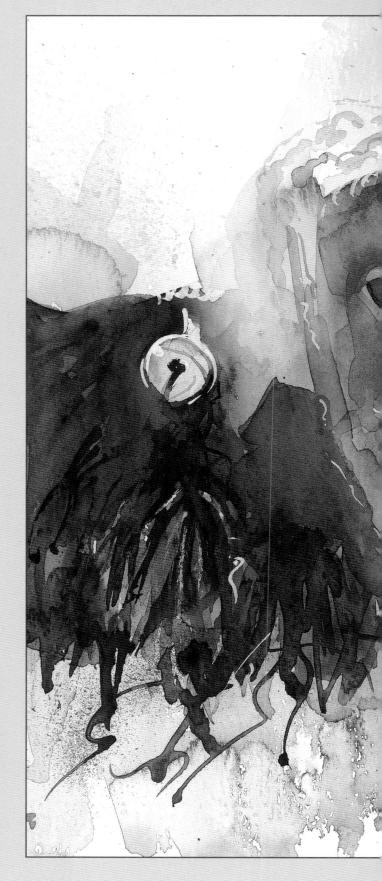

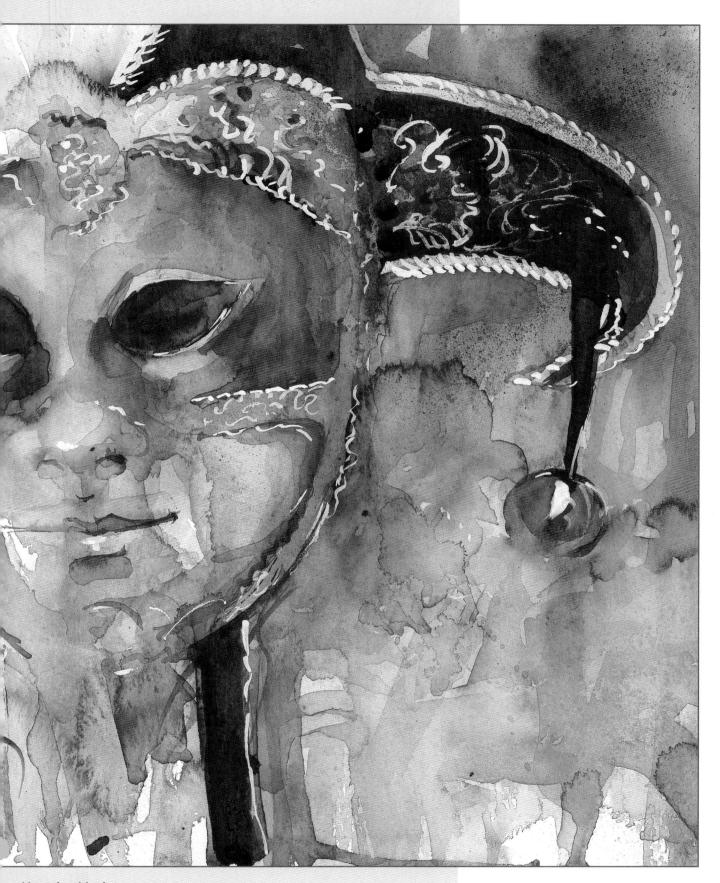

Venetian Mask 71 x 61cm (28 x 24in)

The subject is only slightly off centre with contrasts of colour either side of the mask making use of watermarks for added effects.

Materials

Looking into an artist's studio is like a window into their soul. An insight into how they think, work and create. I have an Aladdin's cave which I venture into with new treasure, whether it is a new subject to paint, collected from a morning walk, or something new to apply pigment with!

Over time my collection of materials has grown, but in it are some very special friends that I couldn't live without. Items I reach for automatically; brushes that work well for me; favourite colours. If I were stranded on a desert island, these are what I would grab to survive with.

As artists we need paper, colour, palette and brushes plus a water container. The items we use will evolve over time as we develop different techniques covering a variety of styles within the magical medium of watercolour. We grow as artists, and our collection of materials grows too.

WATER

For me the most important resource I work with is water, and lots of it. Small containers do not suit my style and I need a constant supply of clean, fresh water at hand. For this reason I often have a number of containers on my art desk and a huge jug of clean water to refill them as I work during the day. Clear containers are excellent for showing when your water needs changing. Always work with two so that one can hold clean water to prepare for loading your brush with fresh pigment while the other can be used for cleaning your brushes in between shade selections.

Tip

You are aiming to achieve watercolours that literally sing with colour and light. Always work with clean water for the very best results as this will ensure you achieve fresh vibrant colours. Using muddy water at any stage will affect your results and could lose the effect of light that you are desperately trying to gain.

Try making a few brushstrokes with discoloured water and see how your paper is affected. This will give you an idea of how fresh pigment can be dulled by dirty water.

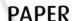

I have painted in watercolour on many surfaces over the years. Not always watercolour paper either, as one of my favourite collections is of Arab faces painted on antique crumpled paper found in an old warehouse while on my travels. In fact I have painted with tea, coffee, wine or anything that was available to capture my subjects. I would grab the first piece of any kind of paper that I could find suitable to work on and cover it in studies that caught my eye at that moment in time.

This is why carrying a sketchbook with you and some basic watercolour equipment is invaluable. Regularly taking notes on colour and form and making sketches train your eye and improve your drawing skills. This makes you into a better artist, and can lead to superb paintings in your studio at a later date based on the records you keep in your sketchbook.

Over the years I have experimented with many kinds of paper surfaces. I've discovered the best paper to work with is dictated by both the subject of the painting and the technique used. What I aim for in my work is a gentle flow of water carrying the pigment, and this is far easier if I choose at the beginning of each project a suitable surface to aid my results. When you are learning or trying out new techniques, it is wise to use reasonably priced paper because many of your pieces may end up in the bin. But as you grow as an artist, you will discover which paper gives you the very best results for your chosen subject and technique.

Paper surfaces can be broken down into two main groups: smooth and rough. Smooth surfaces are wonderful for still-life subjects, or flowers with soft silky petals such as poppies that can be enhanced by colours gliding over the paper. I also enjoy working with rough paper because I adore how the pigment sits in the pockets formed by the texture on the surface. Granulation and colour fusions are aided, allowing colours to merge in some sections and simply sit in others.

Even as a beginner, it is vital to use good quality watercolour paper. You cannot get an idea of how pigment dries or flows if the paper you are using is of an inferior quality. Always work with paper no less than 300gsm (140lb) weight.

Tip

The more water you use in your painting, the heavier the paper needs to be.

BRUSHES

Choice of brush is very personal to many artists. We all have our favourite brushes, and many artists possess large numbers of brushes that they have bought over the years and that have been a 'must have' at one stage or another in their career. The most important thing this experience has taught me is that the best quality brushes really do help me achieve better results, and are far more enjoyable to use.

From travelling and living abroad for so long I have amassed a vast collection of brushes. My favourites are Chinese brushes, given to me by my Chinese teacher while I was living and studying watercolour in Asia. I also still have the very first brushes I bought years ago when I was tempted to buy the latest trends in 'must-have' accessories. This latter collection is doomed to a brush pot that is now purely for show. I sometimes take this into my workshops just to show my students how much money you can waste in an art shop when you don't know what you are doing. I look at the brushes I use now as if they are my best friends. I look after them and I have owned some for a very long time.

The brushes I have used for all the demonstrations in this book are shown below. I sometimes also use a painting knife (no. 2 in the picture). A very large brush, such as a pure squirrel pointed wash brush, size 8 (brush no. 1 in the picture) is ideal for large washes and working on large pieces of paper. It is vital that your brush loads well and holds a lot of water, especially if you are trying the techniques in this book. I also recommend the Winsor & Newton Kolinsky sable range of brushes in several sizes: a size 3 fine rigger (brush no. 4) for dropping small amounts of colour into sections of your washes, and a size 10 (brush no. 3) or size 12 for main subject work are invaluable.

Since writing the first edition of this book, my favourite brushes have become my own personal range that has been specially designed to accommodate my Eastern and Western watercolour requirements. You can purchase wonderful brushes from many suppliers worldwide, so owning a set that suits your personal needs is ideal.

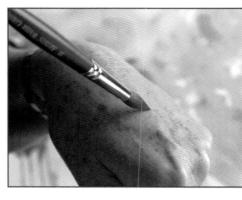

How you choose your brush is interesting. Try brushing the sable tip against the back of your hand. Feel how soft it is and think about the light pressure you are using. Always use this gentle pressure when working so you don't disturb the surface of the paper.

Tip

Use the best quality brushes you can afford. If you look after them well they will last you a very long time and be a wise investment, especially if you love painting. Cheaper brushes tend to lose hair and their fine-point tip, and often split. Never leave your brushes standing in water, and store them upright, with the heads uppermost, in clean, dry, open containers.

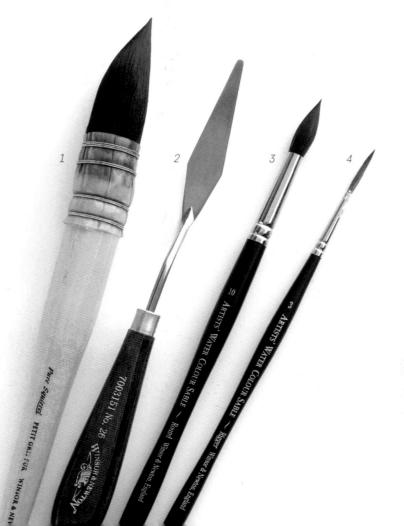

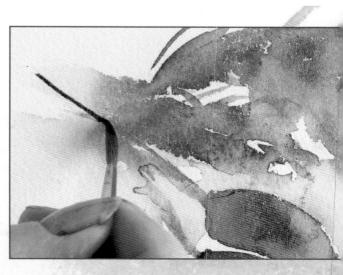

WHY CHOOSE SABLE BRUSHES?

Sable brushes load well, which is vital to enable pigment to be carried over the paper. They have flexible heads, which allows free and flowing movement of the brush. This encourages exciting and varied brushstrokes that, importantly, add interest and impact to your watercolours.

Use a large brush to place washes of colour. Load the brush with a combination of pigment and water and apply with a variety of confident brushstrokes. These brushes are superb for covering large sections of paper, especially background washes.

Use a medium-sized brush for medium detail. This brush is extremely versatile – use it to paint in curved strokes, and to bleed paint diagonally across the painting. You can produce finer strokes using the point of the brush, and broader strokes by dragging the edge of the brush sideways across the painting.

When using bold and almost dry applications of pigment it is possible to draw fine directional lines through the colour to create textural lines.

A small painting knife is ideal for this kind of detail. Please be aware that the surface of the paper should never be ruined by heavy-handed use of this technique. Light touches are vital.

Use a small brush for small strokes. Hold the brush near the tip for more controlled work.

PALETTE

White palettes are wonderful because they give you an idea of the colour of the pigment on white paper. Keeping the mixing area of your palette clean will ensure you always have vibrant, fresh colour in your paintings.

Choosing a palette is a very personal decision, and there are many to choose from. I sometimes mix my colours on paper, and sometimes on the palette. I use a lot of water for soft, whispery washes, so for my technique it is vital to use a palette that has deep wells to contain large amounts of colour and a large area for mixing.

I own a collection of palettes so that I can keep shades for the vast variety of my subjects separate. Portraits, landscapes and flowers all require a different selection of colours. Having a tried-and-tested set of colours to work with helps when I am working on larger paintings, as I can then focus on the subject rather than on what colours to use.

prefer to work with tubes of colour rather than pans and I buy the largest available in my favourite shades. These I empty into my palette, in quantities dictated by the amount I wish to use. These are never tiny dots of colour; they are always huge, delicious, juicy quantities that I find appealing, and which entice me to use them. Get into the habit of placing colour on to your palette and working with it - paint is always far more attractive once squeezed out of the tube. Colour left unused for months is like that outfit you once bought for best but never wore, or the savings you have put away for a rainy day - always there but never enjoyed. Use lots of colour and have fun with it!

Don't try to work with tiny dots of colour on your palette. Enjoy and celebrate using colour from the minute you squeeze it from the tube!

Don't be afraid to squeeze out large quantities of colour into the wells of your palette, and mix your colours confidently using plenty of clean water in the mixing area.

WATERCOLOUR

To achieve a painting that positively sings with colour and light, it is essential to use a watercolour range that is excellent. The properties of each shade, because of the pigment in its make-up, will either add to or detract from your results. There could be nothing worse than buying wonderful brushes and paper and then producing a dull result. To achieve vibrant paintings with colours that are full of life, always buy the best products and learn to use them well.

When I studied art in China I was given a small piece of ochre by my Chinese art mentor. I was asked to grind the pigment from it on an ink stone. When mixed with water it created the most vibrant natural shade of yellow ochre and I fell in love with the brilliance immediately. My Chinese teacher told me how, in her youth, she had to mix every single colour by hand before she could paint. Her teachers would instruct her and she would learn how to choose and use colour wisely.

To be able to buy ready-mixed pigment today is a luxury we often take for granted. We don't have to forage for natural substances that stain or last. Over the years, manufacturers have created wonderful paints for serious artists, and as my painting depends highly on interaction between shades, I avoid inferior products. For the same fresh brilliance and excitement I obtained from the yellow ochre given to me by my teacher in China, I choose from the Winsor & Newton watercolour range, which offers both superb quality and an exciting range of colours.

Due to travelling and meeting artists from all over the world, I am now also a huge fan of Daniel Smith's vibrant watercolours, which I have used in some of the new demonstrations in this book. Trying new colours leads me to unique and exciting results, so I highly recommend you constantly review the product range you use and try something new now and then. This will keep the excitement of painting alive and your enthusiasm refreshed.

The colours shown opposite are all of the colours I have used for the projects in this book, and represent a good basic palette for a variety of subjects. In the demonstration on pages 81–83 I have also used Daniel Smith perylene red, and on pages 90–93 I have used Daniel Smith cascade green. You will also find I use burnt umber at times to introduce darker shades when necessary.

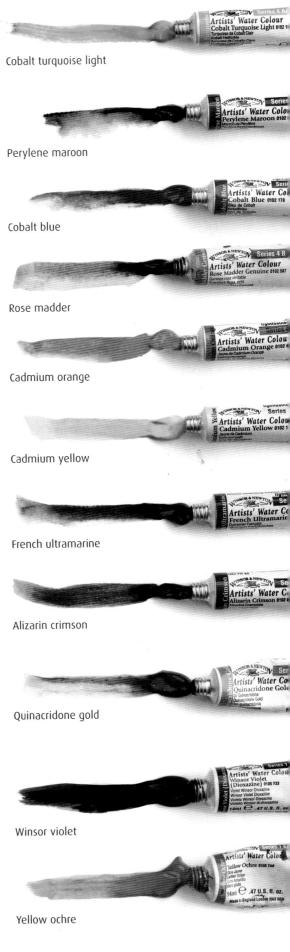

OTHER USEFUL ITEMS

Paper, water, colour and brushes are the main materials for most artists, but in art studios all over the world you will often find other additions to the artist's collection of working equipment. Here are a few treasures to be found in my own studio.

EASEL

I often work standing up at an easel for larger paintings. This gives me freedom to move my arms, which avoids tight, controlled brushstrokes. When working for long periods of time a table easel is ideal for allowing me to paint comfortably seated when adding fine detail and finishing touches.

Whatever I am painting, my paper will be at a similar angle to the subject so that I can capture the positions of the features, light and shadows accurately. Working in this way will automatically give you a good start to achieving a better result. Finding an easel that can be used at a variety of angles is a wonderful asset when working with watercolour. At times, you will need to allow the pigments time to evolve during their drying process. At different stages you will see magical effects. Only time and patience will give you an insight into what is possible with this wonderful medium.

GOUACHE

Gouache is a wonderful way to add light to a painting, but it does need to be used carefully. Keep it separate from your watercolour pigments as once mixed with them it will take on a dull appearance. I keep my gouache on a separate plate or palette.

When you have lost the white of the paper, touches of white gouache can bring a painting to life. Try a small dot in the highlight of an eye or just on the edge of one petal to add drama.

Gouache is fantastic for creating snow effects too. Once you have completed your painting, load a toothbrush with clean, white gouache and splatter it on top of your work. In the snowdrop painting on the right, I held my toothbrush at an angle to create snow falling at the same angle as the snowdrop flower heads. In the painting of a church below, I left white sections of paper for an illusion of snow, then added white gouache to the tops of the hedgerows and trees. Finally, a splattering of white gouache across the central section gives the feeling of distant snow falling softly on this Christmas scene.

Painting at an angle allows pigment to be carried by water, which will flow when drying. This creates interest and wonderful effects.

Tip

Have fun and invent your own texture ideas.

Snowdrop Snow

30 x 39cm (113/4 x 151/4in)

Snowfall created by splattering white gouache adds a beautiful effect to this floral painting.

Silent Night

39 x 30cm (151/4 x 113/4in)

Subtle directional lines in the foreground lead the eye to the focal point of the church. A fine splattering of gouache gives the illusion of snow falling.

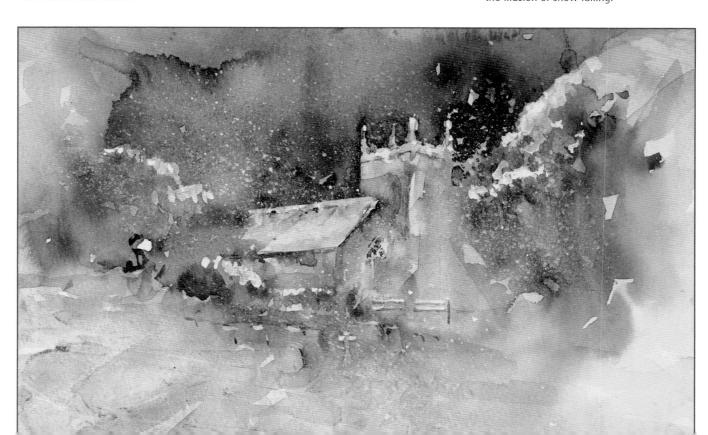

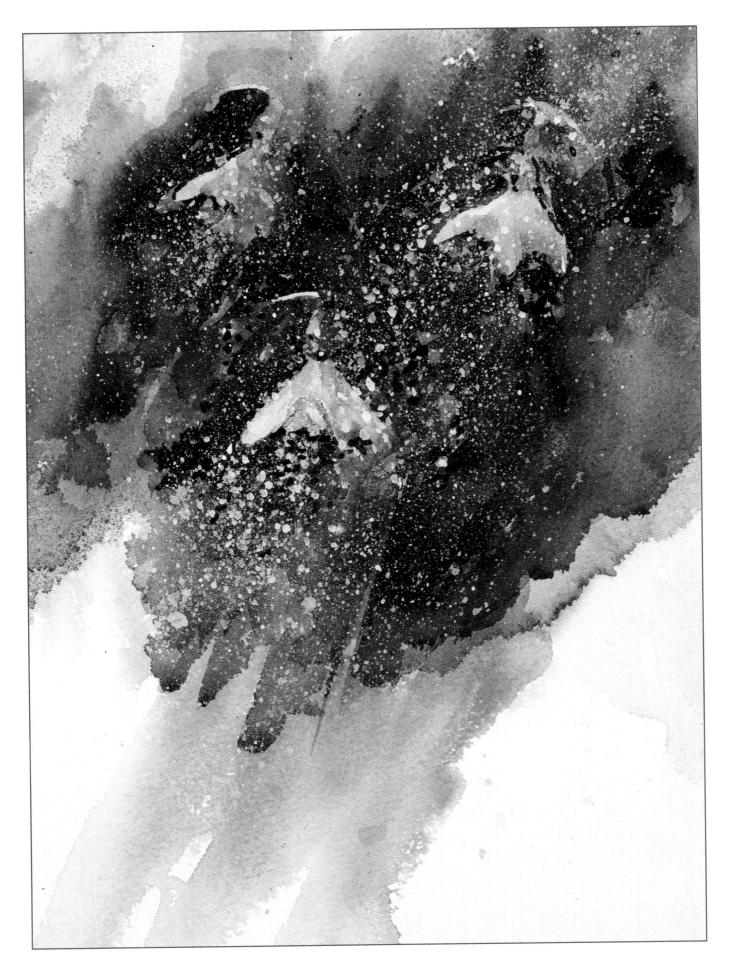

SALT

I find salt invaluable for creating incredible patterns, such as the painting Sweet Pup shown below.

IMAGINATION

I have a small box containing pieces of card and twigs that I have collected over time and which I use in my paintings, from time to time, to create interesting effects. I often use card to paint against to create straight edges of buildings or even vases. I rarely sketch prior to painting, so having some means to hand of achieving straight lines is a great help. I also use card in a similar way to the painting knife (see page 13).

There are many tricks and tips like these that lead to interesting paintings. Always be on the look-out for your next resource that could lead to a new technique or effect. Just about anything can be used to bring a painting to life and prompt the viewer to ask, 'How on earth did the artist achieve that?'. Most artists wish to achieve unique results, so unique techniques are a good place to start.

Sweet Pup

46 x 62cm (18 x 24½in)

Salt was used in the background of this sweet puppy painting to harmonise with the curly texture of the dog's coat. Echoing patterns is a great way to make a painting more fascinating.

Leaving white sections of paper adds interest by forcing the viewer to fill in the rest of the painting using their own imagination. It also adds light in a unique way. Play with a variety of objects and see what patterns you can create. Never dismiss any idea that could give you a new effect. Finding that inner child from years ago, who would eagerly experiment and enjoy playing with colour and patterns, could see you inventing a fabulous new way of working that no one has yet discovered. Make time to be a five-year-old again. Get that freedom and feeling of spontaneous creativity back into your life and your painting. It will show in your results — and in your face — as your imagination comes alive. You may even find yourself smiling more often while you paint.

PATIENCE

Wouldn't it be wonderful if we could find an endless supply of patience? We would never again have to race to finish our work, or attempt to carry on painting when we should be taking time to decide what is needed in a picture, or even whether the painting is actually finished or not. Reading through my materials again I must admit I now can't wait to experiment with washes and texture effects, so I'm going to look at colour next, and the ways in which we can use it.

Song for Spring 38 x 28cm (15 x 11in)

Spring flowers created with subtle use of salt in the foreground to add interesting texture.

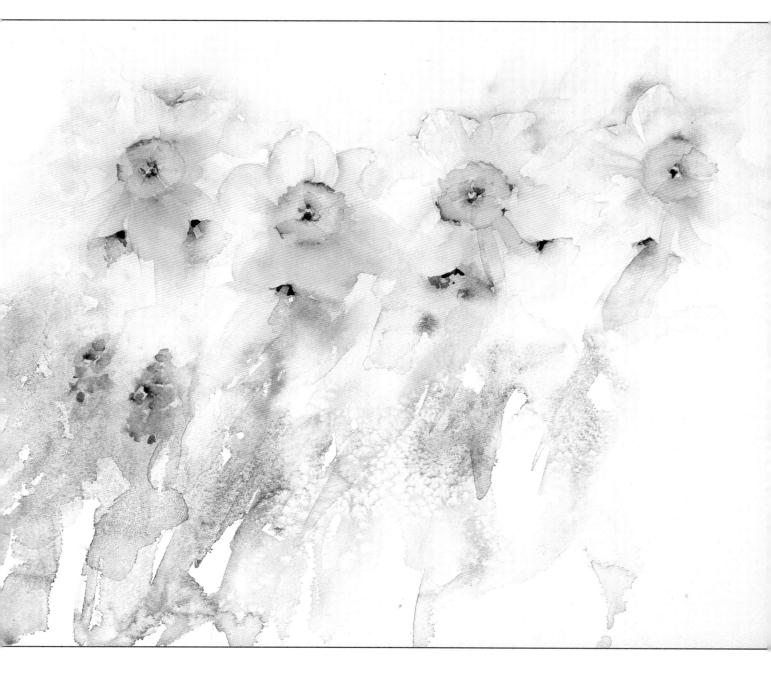

Making the most of brushwork

I use four different-sized brushes in a variety of ways to achieve fabulous results. I hold my brushes at angles to the paper and use very little pressure as I prefer to glide them gently to carry colour or water. Let me explain by a few simple demonstrations.

RIGGER

This is the smallest of my brushes and I use it to create fine lines, add detail or pick up tiny amounts of pigment to drop into wet sections of colour to create interesting patterns.

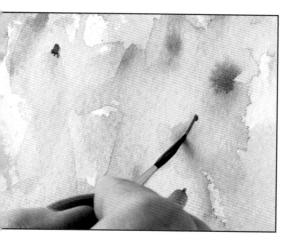

1 Working on a painting of wisteria, I create fine lines in the centre of individual blooms. Gently drawing the rigger downwards and towards me, I leave the first fine brushmark of detail in bold colour.

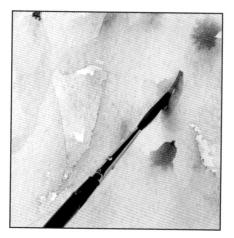

2 I can also load the rigger with clean water to soften my initial brushmark. This is done by simply placing the clean, damp rigger brush alongside the initial brushmark and moving it away slightly to soften the first line.

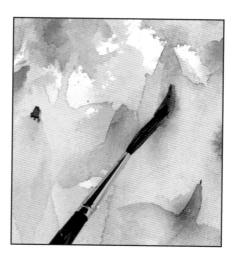

3 I can also use the rigger brush to make small, triangular shapes by moving the tip sideways as it progresses down from the initial placement on paper. I gradually make the brushmark wider by using a different angle when moving the rigger.

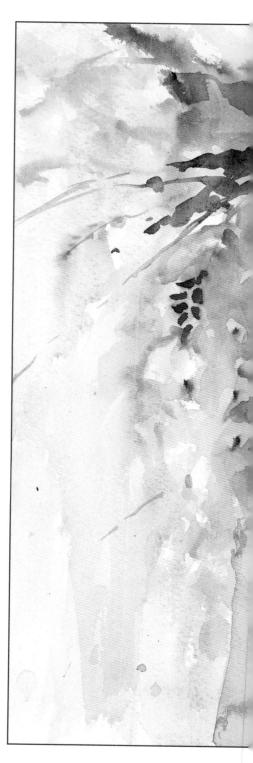

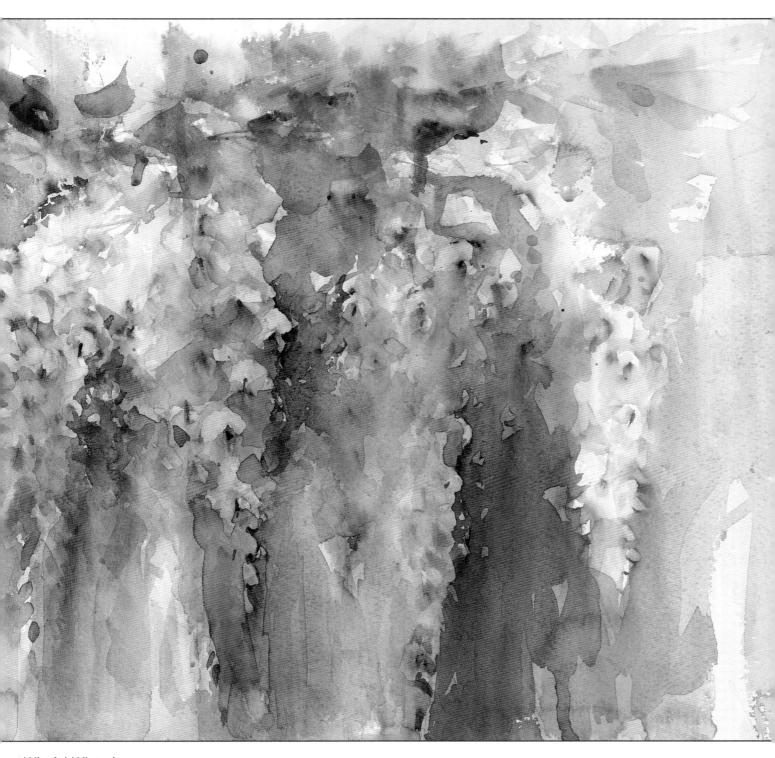

Wistful Wisteria

56 x 38cm (22 x 15in)

I use the rigger to add detail to my work. It is the finishing touches that make or break a painting, and this is often the process that takes the most time, depending on the size of my painting or how much detail needs to be added. I try to avoid overworking and I enjoy leaving sections of my compositions to the viewer's imagination, but without some detail a painting can look abstract.

In the painting above, the fine lines and brushmarks define the flowers and emphasise the darker tones with powerful effect. Light is captured by applying less detail to the blooms that are in strong sunlight, and the careful use of white paper adds to their vibrance.

SIZE 10 BRUSH

This is a gorgeous brush for painting subjects directly.

1 I make small brushmarks to act as starting points for bells on grape hyacinth flowers.

2 Placing my size 10 brush loaded with clean water alongside my first brushmarks, I soften and blur the initial patterns.

Tip

Practise holding your brushes in different ways. Use them at different angles to the paper and try drawing them away from you, not just towards you.

3 Once I have built up the first flower, I repeat the process using violet shades to create a feeling of distance between the main central flower and those alongside or behind it. This will add to the illusion of light that I am aiming for in this small study. Holding my brush at an angle and just using the tip is brilliant for these flowers, or any similarly shaped subjects.

4 Once I have the distant flowers in place I use the tip of my size 10 brush to collect pigment from the background violet flowers and transfer colour by dropping it into my still-wet blue central flower. Using just the tip of the size 10 brush is perfect for many watercolour techniques.

5 Next I add green for the foliage, this time applying my size 10 brush lengthways for a block of green at the base of my delicate flower work. Contrasting block and patterned sections always work well in a composition. I allow the green to flood into the still-wet blue bell shapes.

6 If I hold my size 10 brush further away from the tip and at more of an angle to the paper, I can draw thin lines for a variety of foliage shapes.

7 Cleaning the brush and picking up yellow pigment to drop into the solid green area adds interest to this section.

Tip

Don't be afraid to add bold colour to give your work the 'wow' factor. Contrast soft and bold shades to add drama to a composition. Additions of just a few darks can bring a painting to life in the most powerful of ways.

8 Finally dropping clean water into the fresh wet pigment will form watermarks that will add a fabulous fusion of sunlight hitting my subject. Never underestimate the use of water in your work. Watercolour is made up of pigment and water flow, so use both well!

SIZE 12 BRUSH

The size 12 brush is very versatile. It can be used at an angle to create small detail or lines with just the point, it can be used sideways on the paper, or it can be curved to create beautiful, interesting brushmarks.

1 In this painting I can curve the size 12 brush around the jockey's head to form a semi-circle, separating my subject from the background and trapping light in between the two sections.

2 By repeating this brushmark I can widen and strengthen the background. Notice how beautifully my brush curves.

3 Now I can drag this addition of colour away from the jockey and into the background. This is achieved by the swift movement of my brush into the upper part of my painting. It's a simple move and very effective.

4 If I repeat the brushstroke with what little colour is left on my brush I gain a sense of distance, light and movement. I have given this technique a name: I call it 'forming an echo'.

5 I can repeat this process around other jockeys to form a line, as if in a race. By adding cadmium yellow by dropping it into the still-wet green sections, I bring warmth and sunlight into what could have become a painting with quite a limited palette. By not covering the whole of the upper background with green I am allowing light to flow into my work.

Tik

Forming an echo by repeating brushwork in a composition can give a sense of unity throughout a painting and create harmony.

Tik

Leaving white paper in places is a helpful tip if you wish to create a feeling of sunlight or freshness.

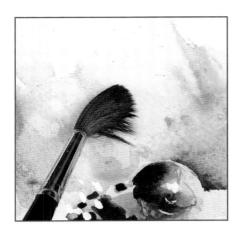

6 By using my size 12 brush on its side and splaying it out, I can drag colour gently into the background, away from my subject. This is done by loading my brush with water first and positioning it next to the still-wet section of green above the jockey's head. Where the colour moves away into the freshly wet section, it will merge and dry with a gentle gradation of colour, again creating a soft illusion of light and distance.

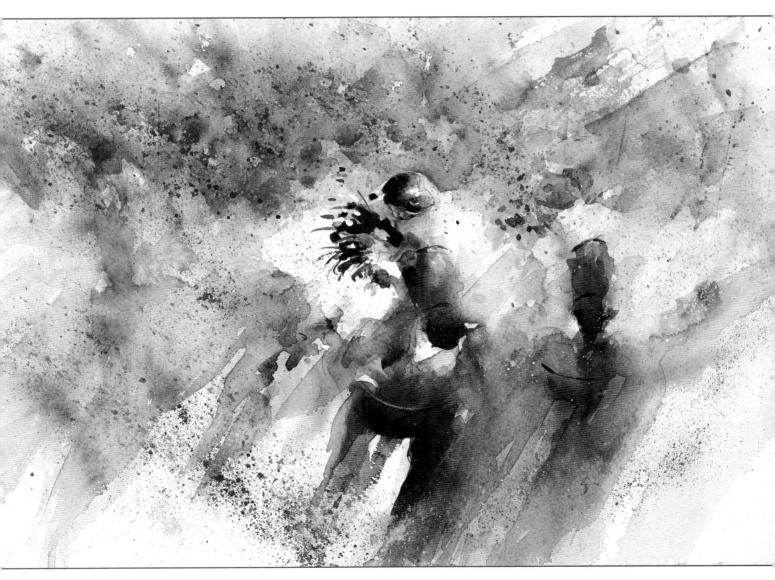

Gaining the Lead 57 x 38cm (22½ x 15in)

WASH BRUSH

I love this brush and often use it to apply washes over paintings that are almost finished as well as to paint brand new first washes. It is wonderful for loading with either water or pigment.

In this demonstration I have a painting of daffodils that is far too quiet. I want to add instant sunshine, and I can do this by layering a wash of cadmium yellow over the whole surface or just in sections where vibrant colour is needed.

Notice how I hold the brush at the far end of the handle. By doing so, I keep my arm loose and create a wide curve over a large area of my work. I start at the top of my painting, which is completely dry, before adding this golden yellow layer as a final wash of colour.

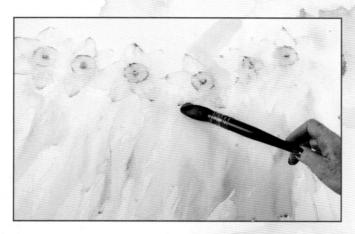

1 Begin with a bold application of yellow in a sweeping movement from top to bottom, in a diagonal direction. This will form a ray of sunlight. I can load my brush with water and soften this first application if the colour is too strong. I want to brighten the colour, not lose the original painting completely.

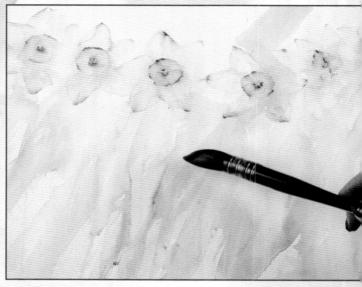

2 When layering washes, work around sections you wish to remain white or cover the whole painting.

3 Gradually moving across the painting, add more yellow pigment to a lively final layer of glowing colour to bring this spring painting to life.

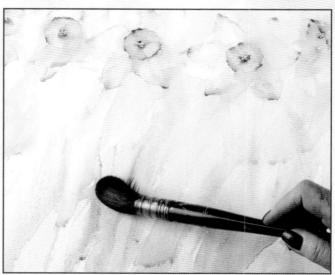

4 Using the same yellow in the foreground layering will create harmony. My wash brush works well held side-on to the paper.

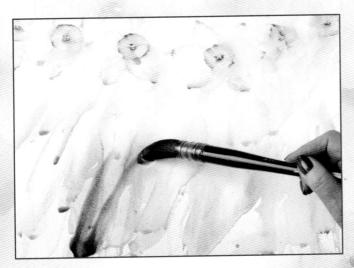

5 I love using backwards brushwork to create leaves and foliage. As artists we often forget to move our arms in the opposite direction from what we're used to. Where you take the brush off your paper is as important as where you put it on. Try practising some backward brushstrokes. It's great fun and very effective.

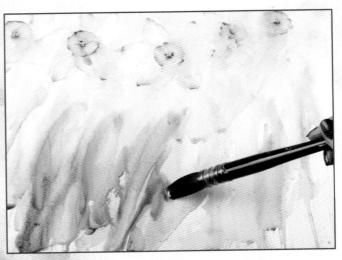

6 Drop more cadmium yellow into your green section to create light and warmth reminiscent of a sunny spring day.

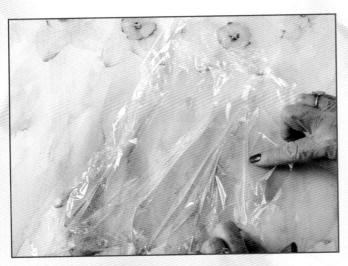

7 Place folded plastic wrap (or cling film) on top of your wet foliage section and with your fingers create patterns to form leaves in your wash. This is a simple and easy technique.

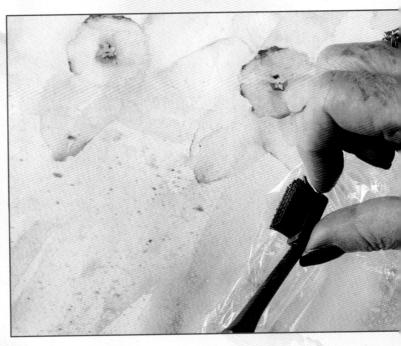

8 To finish the painting, splatter some green into the solid yellow sections to break them up. This is a fabulous way to draw the viewer's eye into areas of a painting that might otherwise have been uninteresting. It also adds a little excitement, and is very enjoyable to do!

Tip

When we are learning, we often create paintings we are not happy with. Don't throw them away – keep them to experiment with. Practise glazes by layering colours or try different splattering techniques. Never throw anything away until you have used every single opportunity to learn from your mistakes or, better still, learnt how to enhance them.

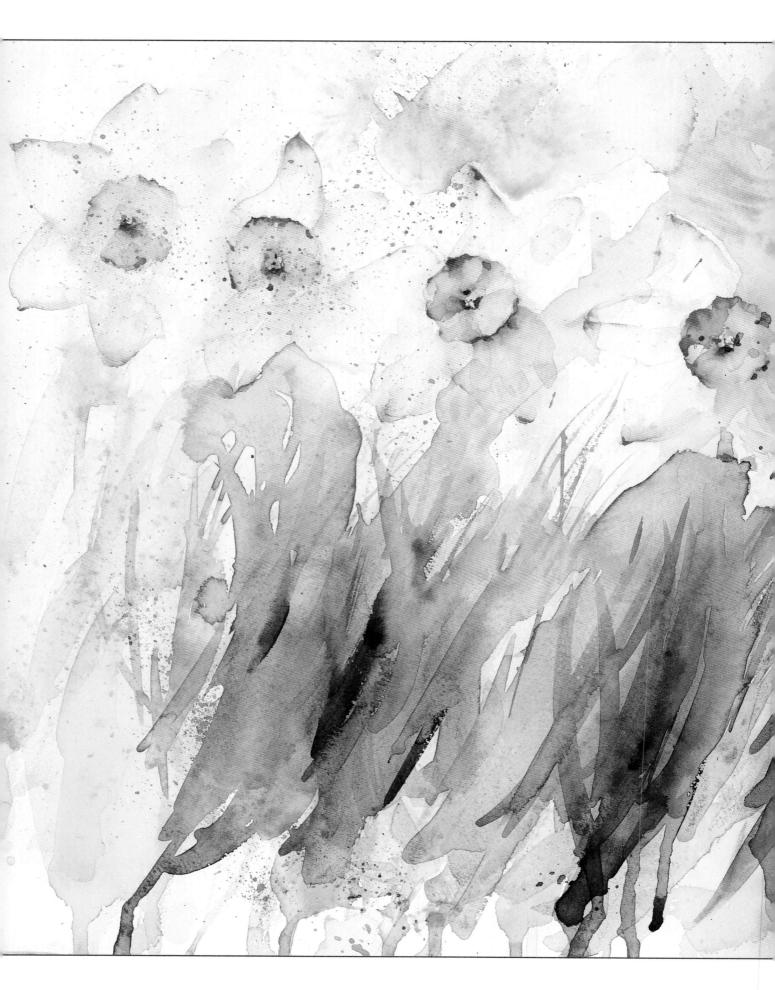

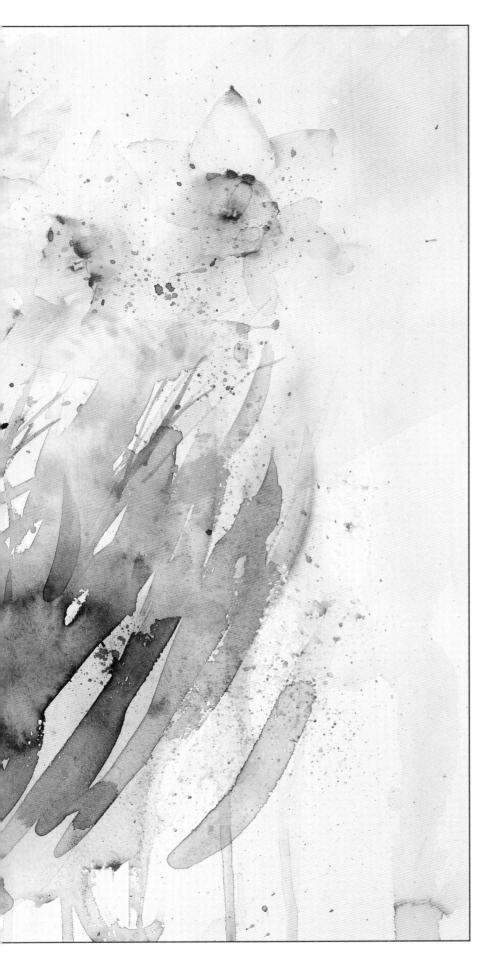

Dancing Daffodils 56 x 38cm (22 x 15in)

Adding stems in the foreground with directional brushstrokes brings a wonderful sense of life and energy to the completed painting.

Sometimes just a few more additions of colour, lines or even splattering of matching colour can create extra excitement in a painting. Leaving petals white on some flowers and allowing the white of the paper to show through in other sections of the foreground and backdrop inject a fabulous feeling of light into this spring painting that bursts with the sunlight of the season.

Colour

I cannot imagine a world without colour. Every day our lives are enriched by what we see, from the minute we wake to the end of the day. The sights around us change with the light from morning to night. How we see colour and how we paint it are a wonderful part of being an artist. Knowing how pigment works so that you can choose the right shade to portray a given subject is also a vital part in working with watercolour as a medium.

Although there are many books available on colour theory, this section covers everything you need to know about how to use colour in your paintings. My practical approach means that from the moment you start reading you will need to pick up a paintbrush and start playing with paint to encourage creative colour mixing for paintings with a more interesting and original appearance. So let's get started!

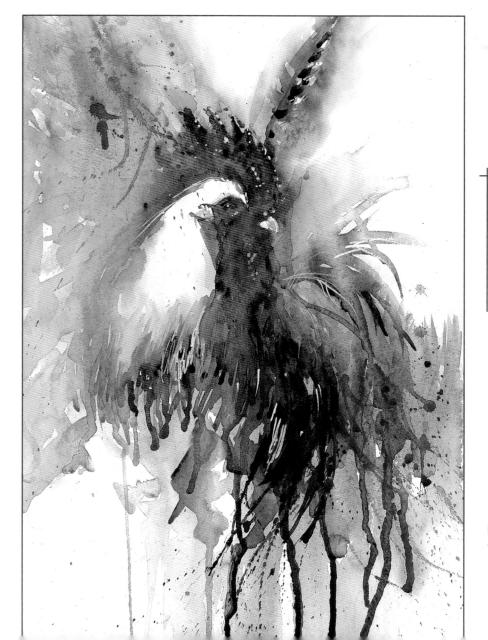

Spring Whispers 41 x 46cm (16 x 18in)

Tip

It takes time to understand colour: how it can improve a simple painting and how it can add to a brilliant result. Time taken reading this section will be enormously beneficial to improving your own work.

King of All He Sees 46 x 56cm (18 x 22in)

THREE PRIMARY COLOURS

To begin you will need a good quality watercolour paper and a clean white palette. Starting with the three primary colours, you can learn how mixing can provide a vast number of shades suitable for the projects later in this book. First, though, you will observe how each of the primary colours interacts with water on the paper. I have chosen alizarin crimson, cadmium yellow and cobalt blue.

In this exercise you will place a small amount of pigment of each colour in a circle on the paper, starting with alizarin crimson. Next to this, with a clean brush, you will place a track of clean water leading away from the circle but not touching it. Then, again with a clean brush, you will gently touch the circle of pigment and sit back to watch what happens. Observation will improve your knowledge of working with this magical medium.

This first exercise, which I have described below, is the best way to start understanding how colour works.

PLAYING WITH COLOUR

Exercises like this one help us to get better as artists. They teach us about pigment qualities, their interaction with other shades and their drying times. They are easy, quick and fun. So let's take the three primary colours red, yellow and blue, and simply play with colour.

RED

Alizarin crimson is a very 'friendly' pigment (see page 33). It interacts well with other shades, it flows well into wet sections on paper and it breaks up easily when water is placed directly on top of it. It is a delightful addition to any artist's palette.

1 On a scrap of paper apply a simple circle of red pigment. Alizarin crimson is ideal.

2 Now, with a clean brush, apply water at the base of the still-wet red circle, not allowing it to come into contact with the red paint. Then touch the area between the wet paper and the red pigment with a clean brush so that colour flows from the circle of colour into the wet area. It will get more diluted and therefore paler as it flows away from the initial application of pigment.

3 Drop water into the top of the red circle and hold the paper at a slight angle. See how fast this causes the red pigment to move, leaving a pale pink line in the centre.

The pigment will gently flow into the wet section of the paper, but not move to the dry sections. Also notice the beautiful transparent colour that is in the diluted area. Do not be tempted to touch the colour or water at this stage. Allow the water and pigment to work alone. Now try this simple exercise again with both cadmium yellow and cobalt blue.

YFLLOW

Cadmium yellow has a completely different formulation from alizarin crimson and isn't quite so friendly as a pigment. In fact, I would say it is quite bossy as it seems to literally push other pigments around!

1 Repeat the previous exercise but this time using cadmium yellow. This is a more opaque shade so it won't move as easily when you add water.

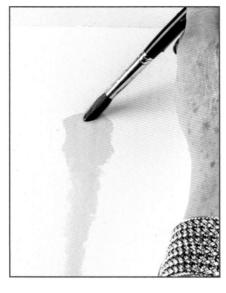

Try this

Build up a collection of shade charts and study the effects created when each shade is mixed and allowed to flow in water tracks.

2 With a size 10 brush laden with clean, fresh water, touch the top of the yellow circle and try to encourage water to run through the pigment. This time it is harder, as the cadmium yellow wants to stay put! Also notice how slowly cadmium yellow flows into a clean wet area.

BLUE

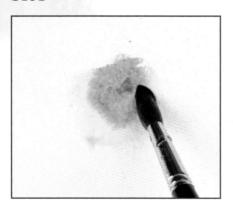

1 Repeat the exercise using a blue shade, for example cobalt blue.

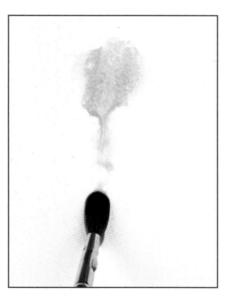

2 If water is added to the top of the blue circle it should flow through the pigment easily and create wonderful watermarks.

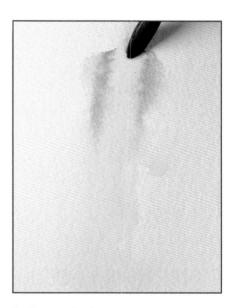

3 The track of water will push through the pigment, and as this track dries, interesting patterns can form.

Tip

Never use a hairdryer to speed up the drying process as this can result in the loss of the beautiful effects that watercolour creates when it is left to dry naturally.

Try using different primary colours. Your results will vary depending on which shades you use. Some shades move far faster than others, and some interact well whereas others do not. Work out which colours flow easily into clean, wet sections, and which colours can be moved quickly by water. Observe what happens when water touches each new colour application. Time the colour flow and observe the pigment interaction. By observing the flow and speed of movement of the colour you will learn how much time you have to work on a large painting before the colour dries.

WHISPERS AND SHOUTS

The gentle colour you see in the flow of the water track in this first exercise I refer to as a 'whisper'. This contrasts with the bold, almost dry, circular application of pigment that I refer to as a 'shout'. In any painting you will find a mixture of whispers and shouts, which contrast and add interest. See *Spring Whispers* in contrast to the vibrant cockerel painting on page 30.

WATER AND COLOUR

It is interesting to note how water plays a vital role in this exercise. Without it the pigment would not flow. This is why we work with water and colour. Never underestimate how important it is to learn how to add the correct amount of water for any given effect. Many artists comment that watercolour is difficult to use as a medium, but if you really understand the beauty of its nature your paintings will always be fascinating — not only in their finished state, but while you are creating them also.

Brilliant primary colours are often used in subjects such as flowers or still life. Transparent, watery mixtures are more commonly used in landscapes, portraits and animal paintings, with results that look highly professional and advanced in technique.

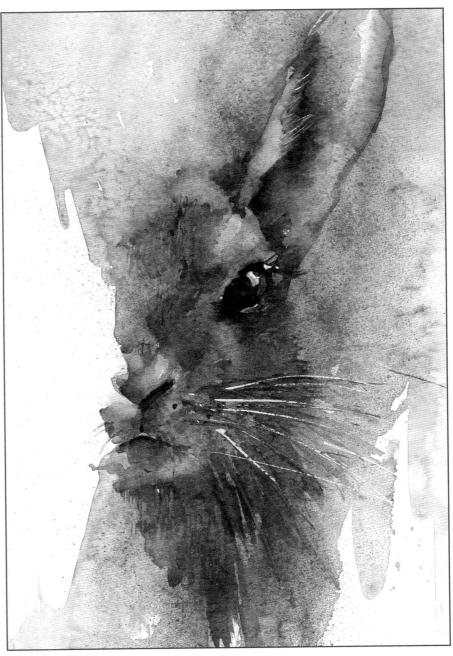

PIGMENT FRIENDS AND ENEMIES

Some pigments are transparent and will flow more easily than others, such as alizarin crimson. Others are opaque and will tend to be slower in their action, for example cadmium yellow. I think of them as people and imagine they all have characters. The transparent shades are friendly and will go anywhere with anyone – they will do whatever you wish. The opaques are more bossy and will try to push everyone else out of the way. They will try to tell *you* what to do, dictating how they want to be used. Shades that granulate, like French ultramarine, will form patterns as the small particles of pigment settle in pockets of paper while they dry. These are therefore my decorative friends.

There is a general belief that watercolour is difficult to control. I suggest that, instead of trying to control it, you should enjoy its many facets and use them to your best advantage. Work with them and become 'best friends' with the medium. It is very easy to fall completely in love with watercolour, and I hope this book will show you why.

Almost Hare 46 x 61cm (18 x 24in)

The colours in this painting were allowed to mix on the paper and not mixed in the palette.

COLOUR MIXING

This is an area that I enjoy very much. Not a day goes by when I don't discover a new shade that will be perfect for a given subject. Time spent mixing colour is extremely valuable because not only does it help us learn more about how to achieve perfect shades for each subject, it also helps us learn how individual pigments work.

MIXING SECONDARY COLOUR

Now we have experimented with single primary colours, let's see how they interact with each other. It's a little like putting a group of strangers in the same room and seeing how they get on! Use the same primary colours as on the previous page.

Keep your colours clean and fresh in these experiments. Make sure your brush holds only clean water to encourage flow into new wet sections of paper. The shades that appear from mixing on paper and not in your palette can be fascinating, and so can the watermarks achieved if you avoid interfering with them.

Bear in mind that you can obtain many more wonderful results simply by adjusting the amount of each colour you mix from the primary selection. You can also achieve many more shades by using different primary colours. Don't be afraid to experiment – it can lead to wonderful colour mixes, which in turn can produce beautiful results in your paintings. Avoid using colour straight from a tube or pan and you will discover an exciting world of magical shades that make your paintings unique. Always be original in your work.

Example of mixing colour on paper. Look at the exciting patterns forming as the colours mix together.

1 Work on a fresh piece of paper and start with the red and yellow pigments. Place a circle of each colour side by side, but not touching each other.

2 With a clean, damp brush touch the central area of the two circles of colour and allow the pigments to merge naturally.

3 Move a clean, damp brush downwards on the paper, away from the merged circles of pigment, and let the pigments flow into it. Now sit back and watch how fast the pigments flow into the clean, wet area. See how the colours merge as they move and observe how they interact. Once you have allowed the pigments to merge let them do so on their own without continually touching them with your brush. Let the paper dry naturally.

knowledge of how the pigments work together. Be a better artist!

Repeat this exercise using yellow and blue. A gorgeous green should appear when the two pigments merge. Finally, repeat the process with the red and blue to create a vibrant purple.

Over time, doing these exercises with a wide range of shades will teach you who your friends are amongst the pigments. You will know which shades stain, which ones flow too slowly or those that dislike interacting. Discover your pigment friends on your palette of colours!

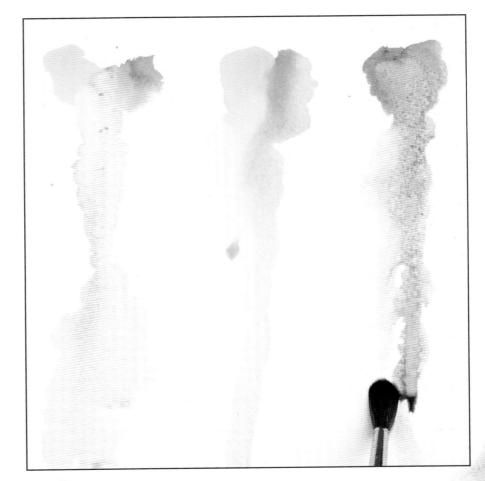

Sea Turtle 62 x 45cm (24½ x 17¾in)

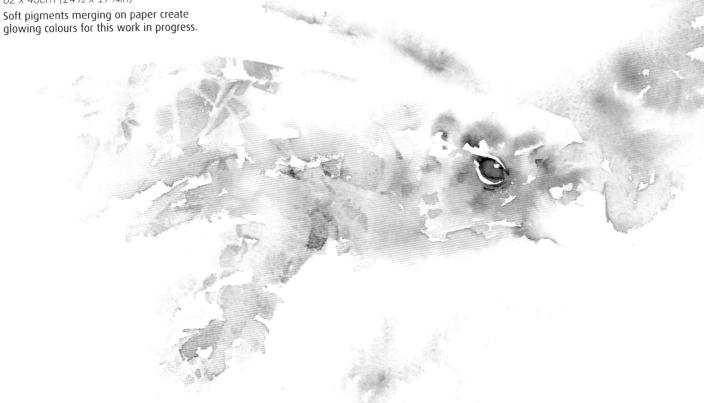

COLOUR SELECTION

The value of taking time to experiment with colour mixing is evident in the beauty of paintings that capture a subject perfectly. The more accurate the colour choice, the more realistic a subject will be. Time taken on colour choices should never be rushed; see them as an exciting challenge, and fascinating to create.

Never attempt to start a painting until you know which colours you will use throughout the piece. It is a surprisingly common mistake amongst artists to get virtually to the end of a painting and then get stuck on a final colour choice, for example the background. Know exactly before you pick up your brush which colours you will be using and where. It is the time taken *before* we paint that makes our results successful.

Understanding the formulation of each pigment will help you create incredible work. Choosing a translucent colour like alizarin crimson and using it heavily diluted will give you a wonderful colour choice for a tomato. When combined with an opaque cadmium like cadmium red you have the winning combination of a bossy friend pushing a kind one out of the way, which gives a wonderful interplay of personalities on paper. Get to know your watercolour friends and how they interact.

HARMONY AND CONTRAST

Once you have chosen the right shade for your subject think about what colours would work best in the background. What shades complement the subject, or add impact or drama? Create harmony for quieter paintings and bold contrasts for stronger images that demand this kind of attention. Study your subject in different light for guidance on which colours to select.

SUPERMARKET CHALLENGE

Finding new things to paint while shopping in the supermarket can be a fun challenge. In the exercise below, a simple vegetable gets the watercolour treatment in an exploration of colour, technique and brushwork. Colours are allowed to flow, as in the previous exercises, to create a row of Brussels sprouts. Let your imagination pour into your work and constantly keep your eyes peeled for unusual things to paint and brilliant new ways to do so.

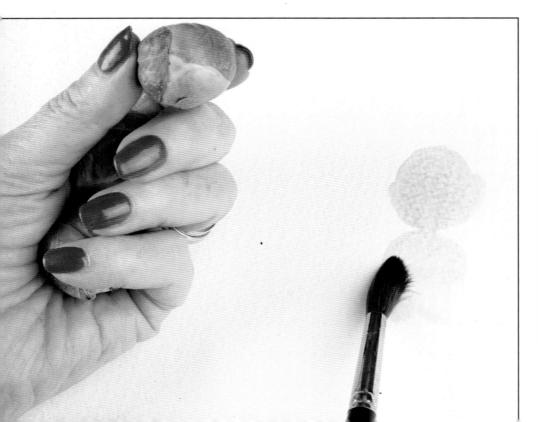

1 Paint a soft wash for your chosen subject in suitable colours. Look for a variety of shades to make your painting interesting.

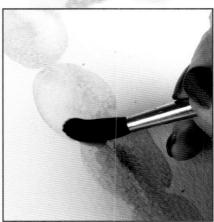

2 Add texture to help create a more interesting result. Here I have used plastic wrap (or cling film) to form the leaves of the Brussels sprouts.

3 Allow colours to run into neighbouring sections to form harmony throughout your composition.

4 Add detail, but only enough to complete your painting and make your subject recognisable.

Tomato Medley 20.5 x 41cm (8 x 16in) over the illusion of

An example of translucent shades giving the illusion of light and sheen.

Light and how we see it

LIGHT OR INTRIGUE?

I have often considered that I may see things completely differently from a non-artist. A friend can see sunlight, whereas I see how the sun's rays affect everything they touch, creating complex patterns that can change a simple subject into a vision of intrigue. I strongly believe this is the key factor in creating an excellent painting. A touch of mystery will draw the viewer back to a painting for a second or a third glance. The ability to see light and capture it creates magic that takes the boring and ordinary into the realms of incredible and extraordinary.

Frog in Autumn Leaves 35.5 x 25.5cm (14 x 10in)

The subject formed out of a first wash of exciting colour. The attraction of this subject was the brilliant sunlight hitting the frog's head.

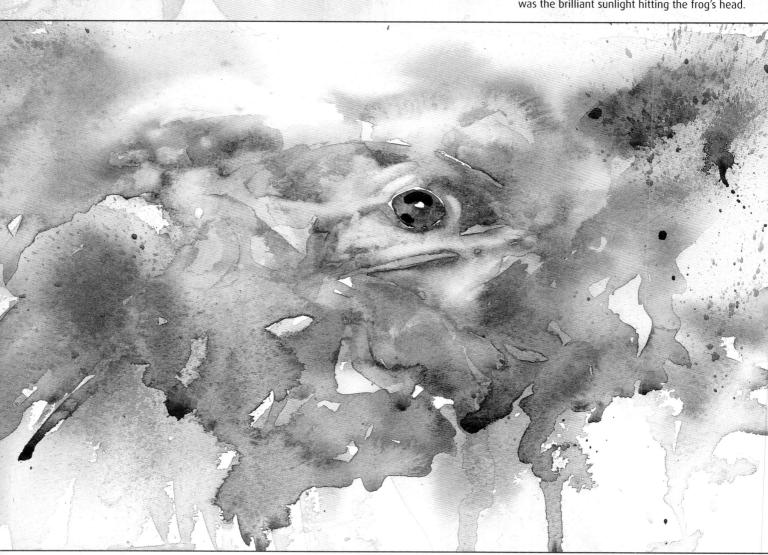

Throughout the day, light can make the same scene appear completely different; sometimes forming a halo or a silhouette, and at other times making shadow patterns from a subject's form. It is absolutely fascinating. Every way I turn I see new possibilities for paintings, each with a unique set of qualities that brings it to life.

Little Duckling 36 x 38cm (14¼ x 15in)

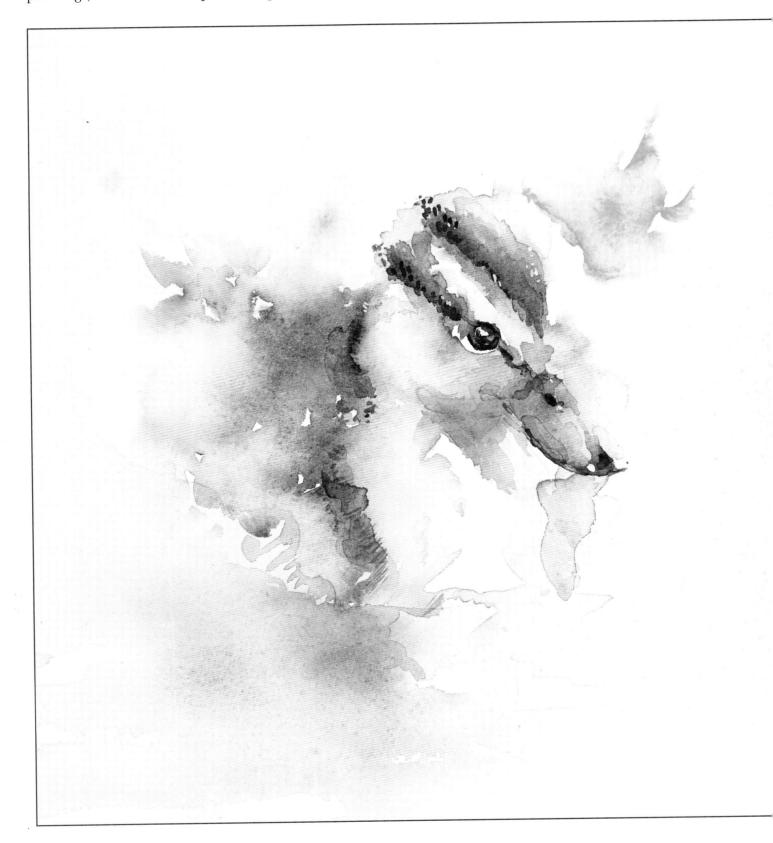

THINKING AS AN ARTIST

The main aim when we pick up our brushes is to create a painting that is unique and interesting – one that evokes emotion or brings a subject to life. To achieve this sense of feeling in our paintings we need to see in a way that excites us. We need to be able to recognise immediately what could make a great painting, and then know how we can use colour and light to create a magical interpretation of any given subject.

SIMPLE HIGHLIGHTS

By wise choices of colour and clever handling of light, the simplest of subjects can become the most fascinating. When new artists try to think about what light means, they often imagine a highlight in an eye or a light section that brings a small subject to life, as in the painting of rosehips opposite. Here, light shining on the round fruits brings a large painting to life, when in fact this is just a very simple autumn scene. It is the highlight and rich colour that make this composition work.

Autumn Glory 71 x 66cm (28 x 26in)

A combination of directional brushstrokes and vibrant use of colour gives the viewer an illusion of light hitting the subject.

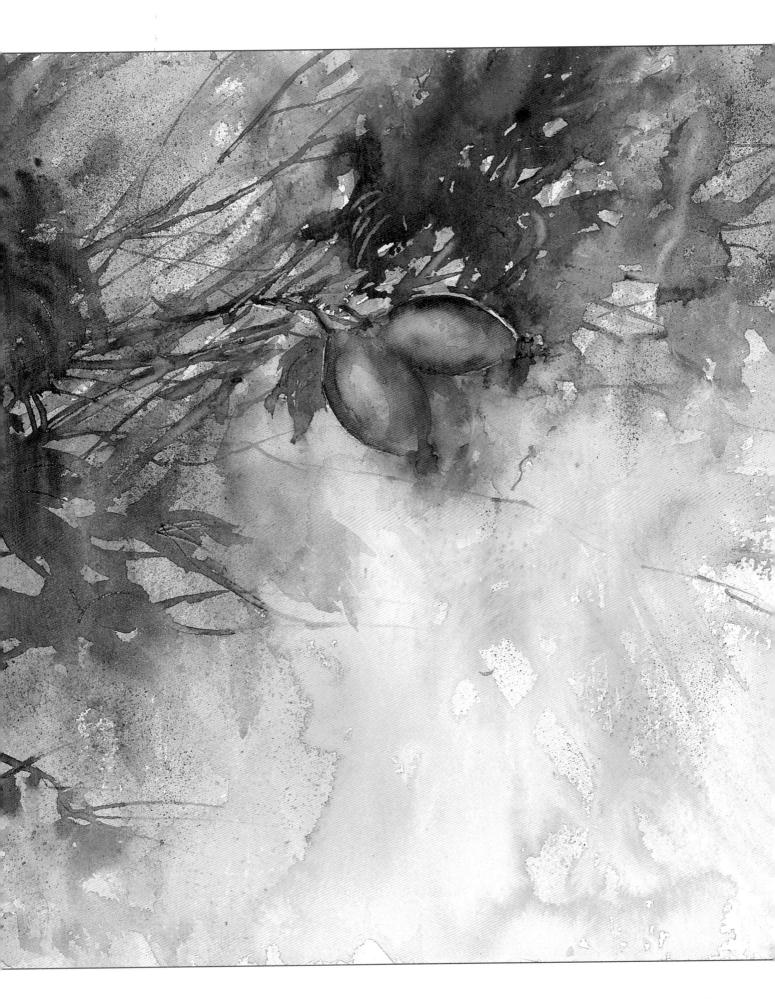

SEEING LIGHT

How we see light is what makes us unique as artists. If you look closely at the painting of two goats you will see a subtle line of light on the back of the goat nearest to you. This was the main focal point for me – not the animals. It was the light that attracted me. It immediately caught my attention when I first saw this scene in Turkey. The whole painting evolved around this small area. Where I couldn't see clearly due to the intense sunlight I omitted detail. The head of the goat in the distance is less clear than that of the goat in the foreground. I was quided by my passion for seeing light.

Look at the original scene in the photograph of the two goats grazing. Discover how sections of light make this work as a composition. If we dismiss the light, we are left with a very ordinary scene. Add light, and it instantly becomes far more exciting. Take time to observe the line of light and think about why you think it attracted me. Later in the book I will talk about a technique called 'trapping the light', which is a way of working with scenes such as this one (see page 54).

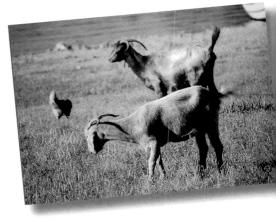

A photograph of goats in Turkey. Study the patterns created by light.

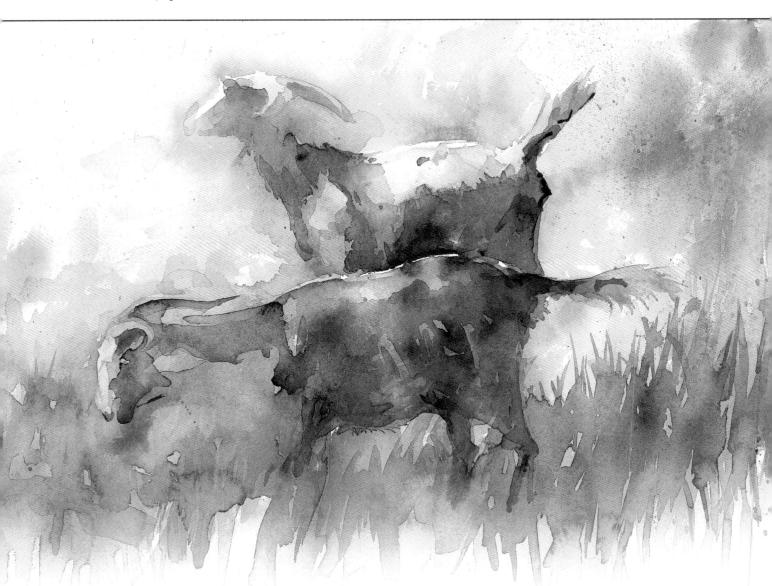

Just Grazing 51 x 46cm (20 x 18in)

Observe how this painting is created using blocks of colour as opposed to painting a goat literally.

LIGHT ILLUSIONS

By seeing light and learning how to incorporate it in our work, we can create illusions. We can draw the viewer into seeing a sunny day, imagining movement and so on. Look at the painting of a gondolier opposite and try to imagine this was painted with the subject in the shade. It is impossible, isn't it? Now look at the original photograph taken in Venice. By using my imagination and subtle colour changes, I have given the impression of sunshine. It is well worth learning how light can dramatically create more interest in a painting.

So, before we even pick up our brush we need to think about where light plays a part in the composition, and to observe how it impacts on the subject.

Gondolier Study, with play on light 20.5×30.5 cm $(8 \times 12$ in)

A study changing the source of light from the original photograph taken in Venice.

LIGHT AND THE ARTIST

Before we can even begin to paint light, we have to be able to see it. Once you start to look for light it becomes an addiction. No painting feels right without it. It becomes a part of your being as an artist. You find yourself searching for ways to bring light into your work, and even more ways to paint it. In the next section we will look at how we can paint light.

IMAGINATIVE LIGHT

We may not always see real light, but once we have understood how it can turn the simple into the magical, we can look at subjects with an artist's eyes and bring them to life more dramatically. We can give the viewer's imagination a part to play in any painting. Is there a feeling of light dancing on these roses, or is it just a trick? Is the artist forming an illusion, disguising what is really there? The missing detail gives the impression that brilliant sunlight is playing with what we can and can't see.

Summer Celebration

56 x 38cm (22 x 15in)

There are so many ways to paint different subjects. In this version of roses in watercolour, the petals were created by using plastic food wrap (or cling film). When the colour was still damp, I placed the plastic wrap on top of the pigment using circular movements to create curved patterns on the flowers. I deliberately created small shapes in the centre of each rose and made them progressively larger as the petals got bigger, radiating away from the central point. This is a wonderful demonstration of how using our imagination and mastering techniques can lead to more unique and varied results. The light bursts through this painting by leaving white paper between the stems in the lower half of the composition, and the use of warm colours to depict sunshine in the upper section behind the blooms. Colour can add light in spectacular ways. Never underestimate its uses!

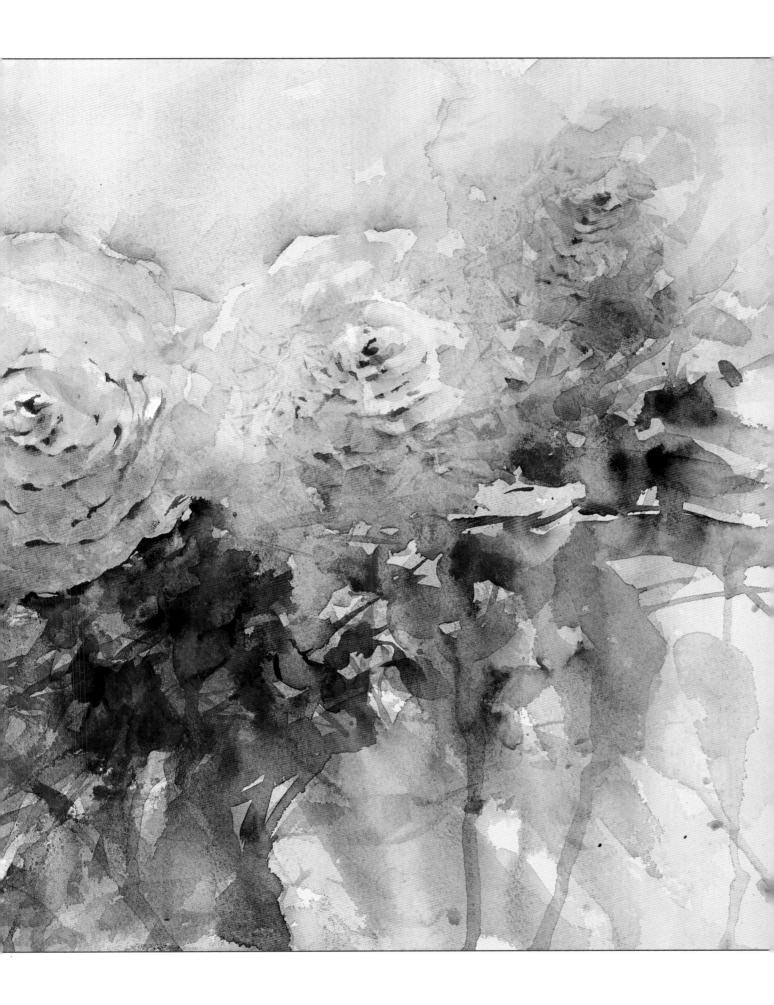

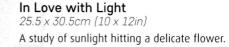

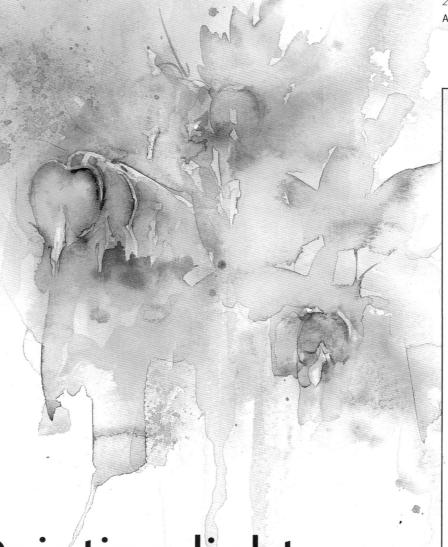

Painting light

If you think seeing light is exciting, try deliberately setting out to paint it! Put the subject completely out of your mind and focus only on where you can see light. It is a fascinating exercise. All of a sudden your whole world becomes a far more interesting place as you observe brilliant colour combinations. You begin to see in a different way, nothing is boring any more, and everything around you becomes potentially far more interesting to paint. Simple things, like the way a shaft of light falls on a single blade of grass, or a single petal on a daisy that is a brilliant white compared with the others because it is in stronger sunshine, become abstract compositions just waiting to be captured on paper. You start looking for highlights and shadows. You notice how the sun's rays affect buildings and architecture. Introducing light into our paintings injects them with a feeling of life, and there are many wonderful ways of doing this.

CHOOSING COLOUR THAT PORTRAYS LIGHT

So, how do you start to paint light? One of the most obvious options is to choose colour that brings an instant feeling of warmth and sunshine into your work. Bright shades can portray light beautifully. Contrasts of cool colour located against warm shades also work well.

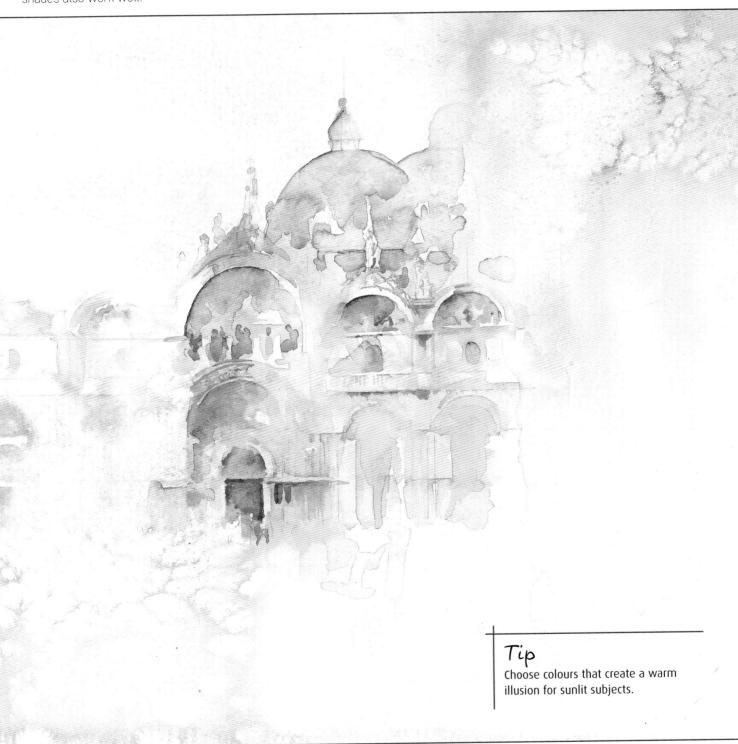

St Mark's Study, Venice

56 x 38cm (22 x 15in)

In this study of St Mark's Basilica in Venice, a selection of cadmium orange and quinacridone gold gives an illusion of the building being hit by brilliant sunshine. Inconsistent depth of the same colour throughout the study also creates the illusion of sun rays hitting the façade.

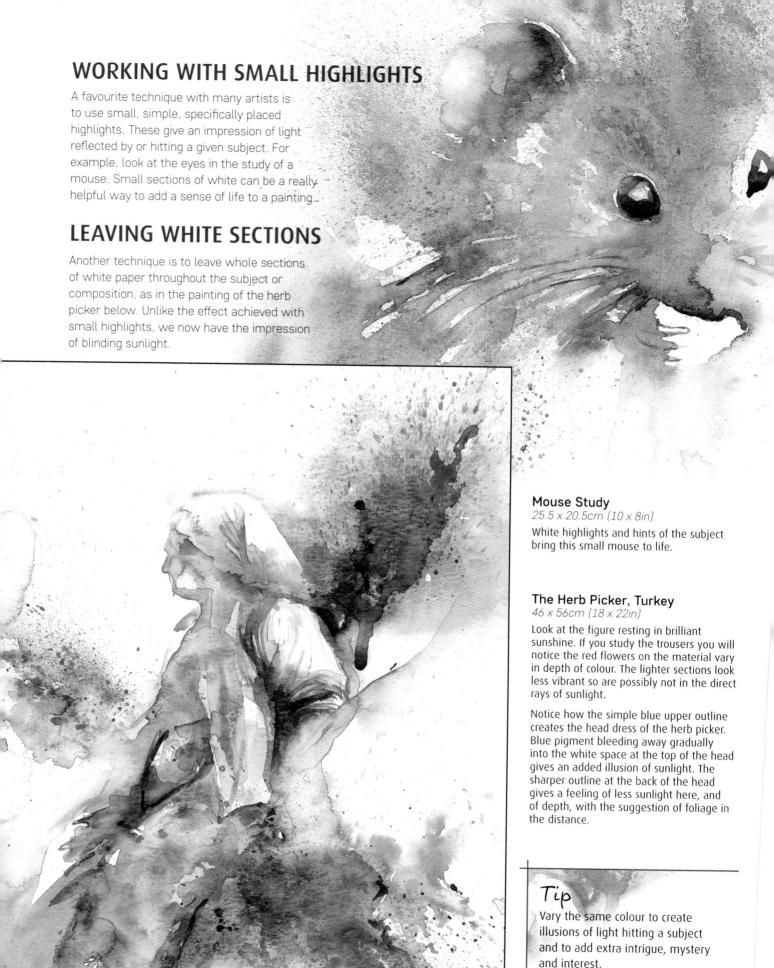

BUTTERFLY STUDY

We can achieve light in a painting in so many ways, for example by using colour that depicts sunlight, or by leaving sections of a painting missing to create an illusion of light hitting the subject. The options are endless. This simple demonstration is a way of pulling some of these ideas together. My aim is to paint a butterfly by painting only half of my subject and by deliberately omitting too much detail.

Subjects that move are interesting, especially if they move frequently and quickly, as butterflies often do. Rather than aiming for a study that is full of information I am going to leave most of it out. I will therefore paint the body of the butterfly and just one wing, telling the story but with as little information as possible.

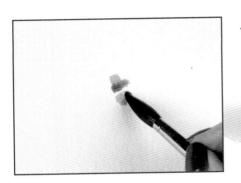

1 Start by finding a point you can work away from. In this case, the head of the butterfly. This acts as your starting point.

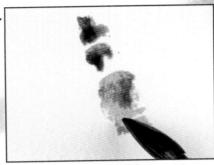

2 Gradually build up the body of the butterfly, but leave some sections here white as light will be hitting this part of your subject too. Use curved brushstrokes even though this section is small.

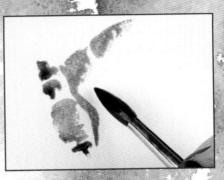

3 Add the beginning of the wings, side-on to the body outline, and gently bleed this colour away to form the upper wing.

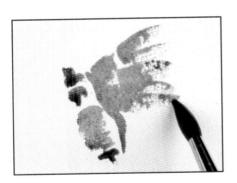

4 Next, paint the wing shape, leaving white paper showing in places.

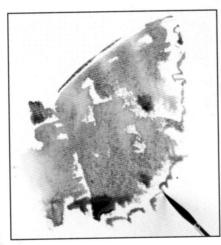

5 Once the wing is defined, introduce another colour. Drop in some violet to the still-wet wing sections. Use a rigger brush to form a fine, pretty outline to the wing. I am deliberately leaving white sections throughout this study to create a feeling of lightness and transparency on the delicate wings.

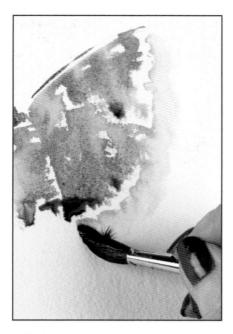

6 Soften the hard wing edge with fresh, clean water on your brush to create a feeling of movement in the finished painting.

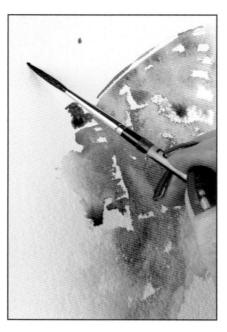

7 Place two small dots to help you position the antennae.

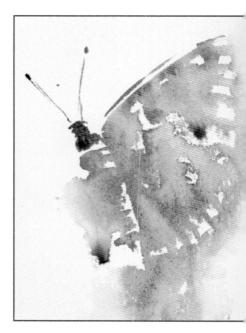

8 Add fine lines for the antennae. Soften the wings too. This avoids solid areas that could give your painting a wooden rather than lifelike effect when finished.

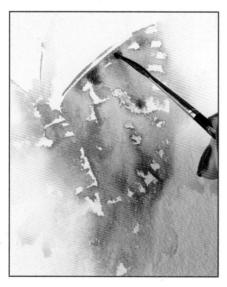

9 Now strengthen your painting by adding the dark patterns on the wings.

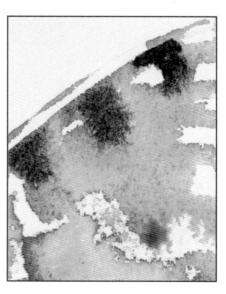

10 The dark pigment will merge with the still-damp violet area.

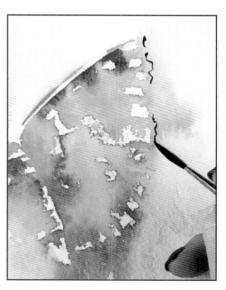

11 Dropping touches of the dark from the wings into the centre of the body adds depth and creates harmony.

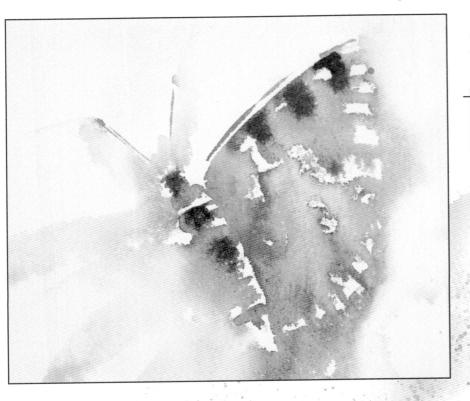

12 Your finished study will have light and interest. The area on the left appears as if it is in vibrant sunshine.

Tip

Experiment with layering colour to add sunlight and warmth to a painting. Practise on small studies by adding colour in a variety of ways to create light, shadow or warmth.

13 You could now add a yellow wash as a background. The yellow shade acts as a sunlit wash over the whole butterfly study and, when dry, creates the warmth of a summer's day. By allowing the yellow to glide over the subject below, it acts as an interesting top layer.

USING DARK CONTRASTS OF COLOUR AGAINST LIGHT

A very common technique for painting light is to use dark colours against a light area to create a strong contrast. This not only gives an illusion of light, it also creates a background that makes the focal point far more dramatic. This is demonstrated well if you look at the dark colour against the lighter section on the main elephant's head in *Almost There*. Here, the flash of turquoise makes a creative impact on the finished painting. It is unexpected and brings excitement to an otherwise uncomplicated mixture of harmonious colours.

Almost There, Africa 61 × 51cm (24 × 20in)
Leaving sections for the viewer's imagination creates magical interest.

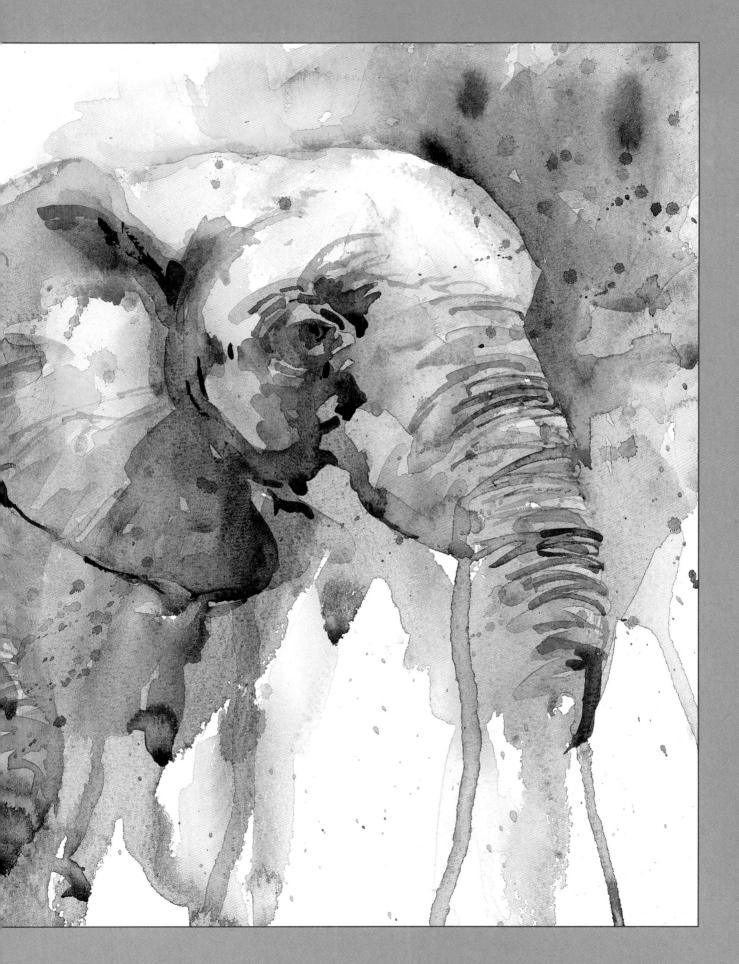

TRAPPING THE LIGHT

There are times when you can clearly see subjects surrounded by light, almost like a halo effect. Light sections around the hints of figures in the background of Walking in Murano opposite creates an illusion of brilliant sunlight. At times you can clearly see a well-defined line of light trapped between two subjects, as in the painting of goats grazing on page 42. This is a wonderful time to use a technique called 'trapping the light'.

COLOUR FUSIONS

Losing detail and allowing colours to merge can soften a painting and give a wonderful feeling of movement. See, for example, the painting Walking in Murano opposite. It can also create a sense, again, of blinding sunlight. Too many tiny details can be distracting in a painting. Always simplify your work and keep the attention on your main focal point or confuse the viewer with expressive application of colour.

CAPTURING LIGHT COMBINATIONS

There are many ways to incorporate light in a painting: clever use of colour, leaving sections white, adding highlights, blurring detail with lost and found edges. A combination of all or any of these techniques can result in an incredible painting one that not only intrigues the viewer but also gives pleasure to the artist whilst the painting is being executed.

In the next section we will look a little more closely at some of the techniques used, and start pulling together all of the ideas described so far on how to see and paint light.

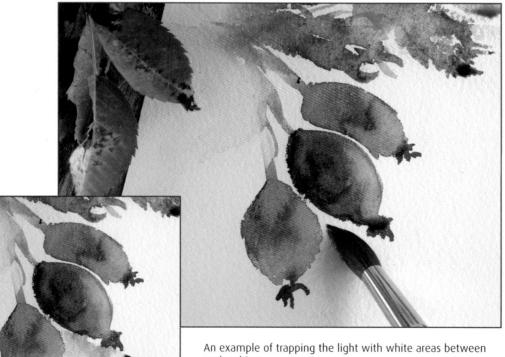

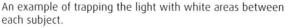

Softening edges can give an illusion of life and movement.

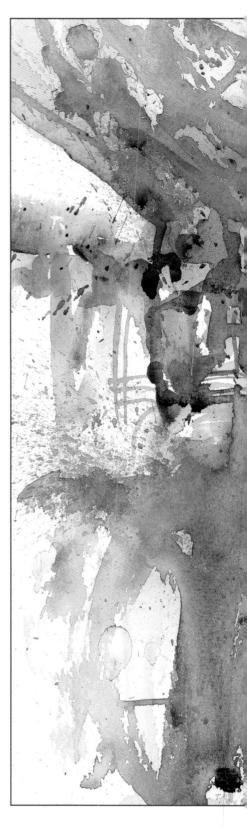

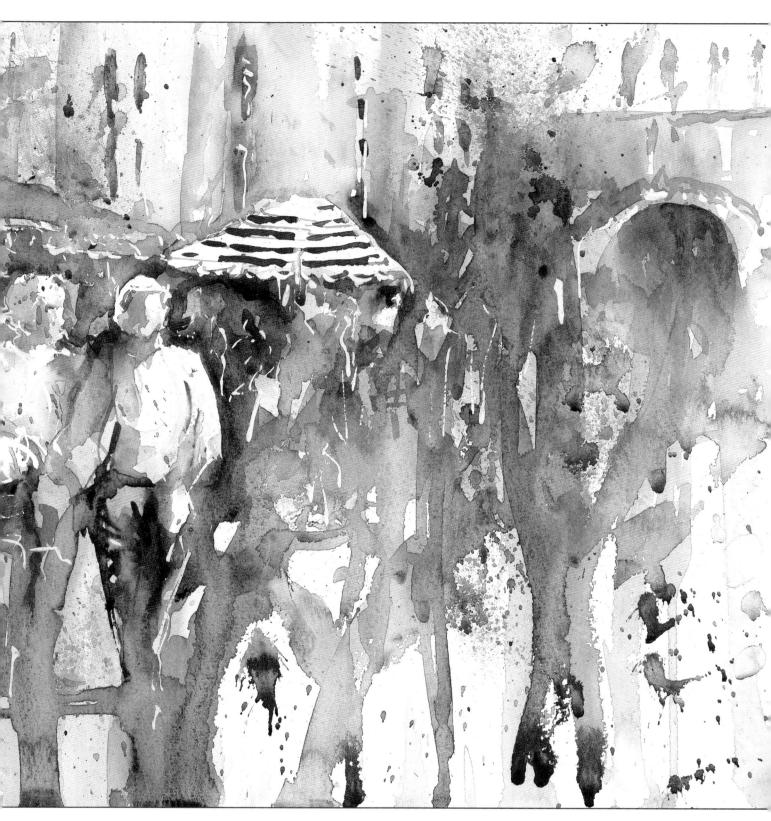

Walking in Murano 61 x 56cm (24 x 22in)

Lost and found edges with fusions of colour create a sense of light hitting both subjects and their surroundings on a brilliantly sunny day in Murano.

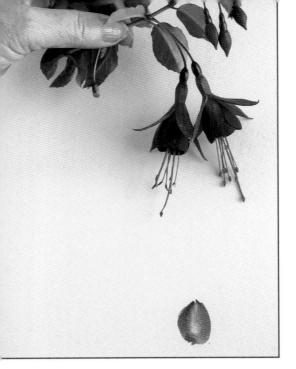

1 Look at the subject closely, then start by placing neat colour onto the paper.

FUCHSIA STUDY

Here is a simple exercise in painting colour and light minus the use of a preliminary sketch, using everything you have learnt so far. Try this, then learn about the techniques you can use to help you excel as an artist.

2 Load your brush with clean water and pull out the pink sepals using curved brushstrokes.

3 Load the brush with neat pigment and drop it into the wash. Allow the colour to blend on the paper, resulting in colour fusions.

4 Using neat pigment, paint in the purple petals. Take the colour into the red and allow them to fuse on the paper.

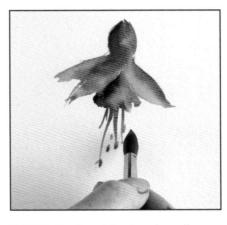

5 With the tip of the brush, pull down some stamens and dot the anthers on the ends.

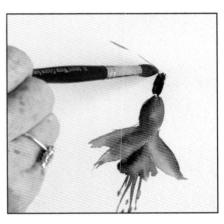

6 Put in the ovary and stalk at the base of the flower.

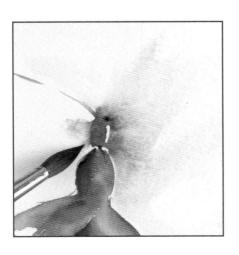

7 Lay on water around the righthand side of the ovary and bleed out the colour. Dampen the left-hand side also and soften.

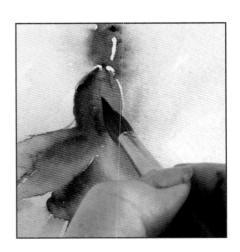

8 Leaving a white space around the subject to trap the light adds interest.

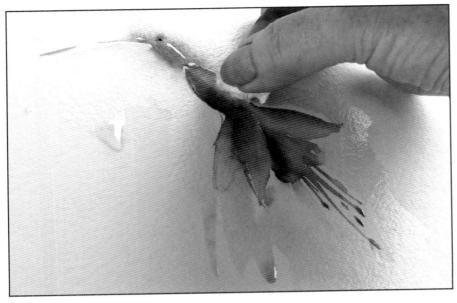

9 If necessary, lift a small highlight with tissue.

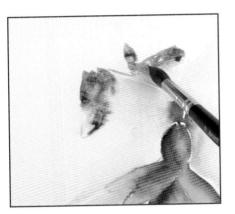

10 Put in the leaves on the stalk.

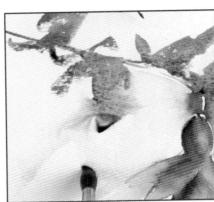

11 Soften edges with clean water for an illusion of movement.

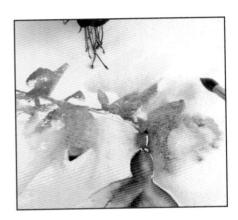

12 Build up the painting gradually.

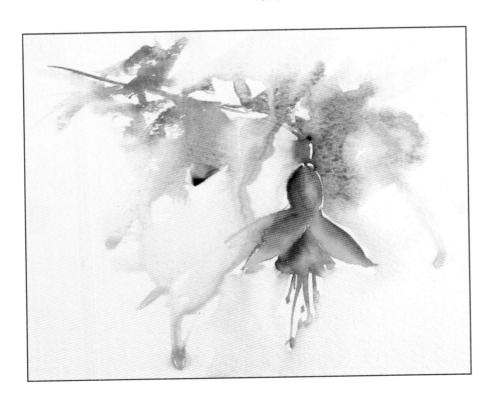

Fuchsia Study
Stop when you feel you can see your subject. Do not overwork or worry about adding too much detail.

Techniques

When I first started painting I studied numerous basic techniques. Many I still use, while others I have completely discarded. I have grown as an artist and my style has evolved; over time, I have created my own way of working. What once seemed difficult when I was a beginner has now become easy with practice and, dare I say, what I first learned years ago now seems so boring. It is far easier to explain what I mean by looking at my favourite techniques in watercolour and how I have adapted them to make my own work original, more exciting and unique.

Bleeding colour away from a negative space.

WASHES

Every artist needs to start at the beginning, so working with basic washes is a wonderful way to learn how to work with this magical medium. Washes allow pigment to flow and cover paper in a variety of ways. A simple wash can make a beautiful backdrop for a sky, whilst placing a complex wash in the foreground can really add impact to the most peaceful of scenes.

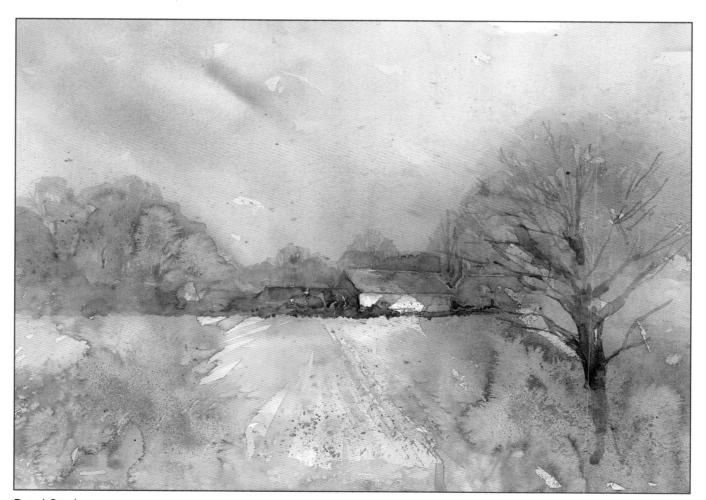

Rural Study $61 \times 56cm (24 \times 22in)$ Basic washes with a touch of excitement as 'old' meet 'new' techniques in a landscape.

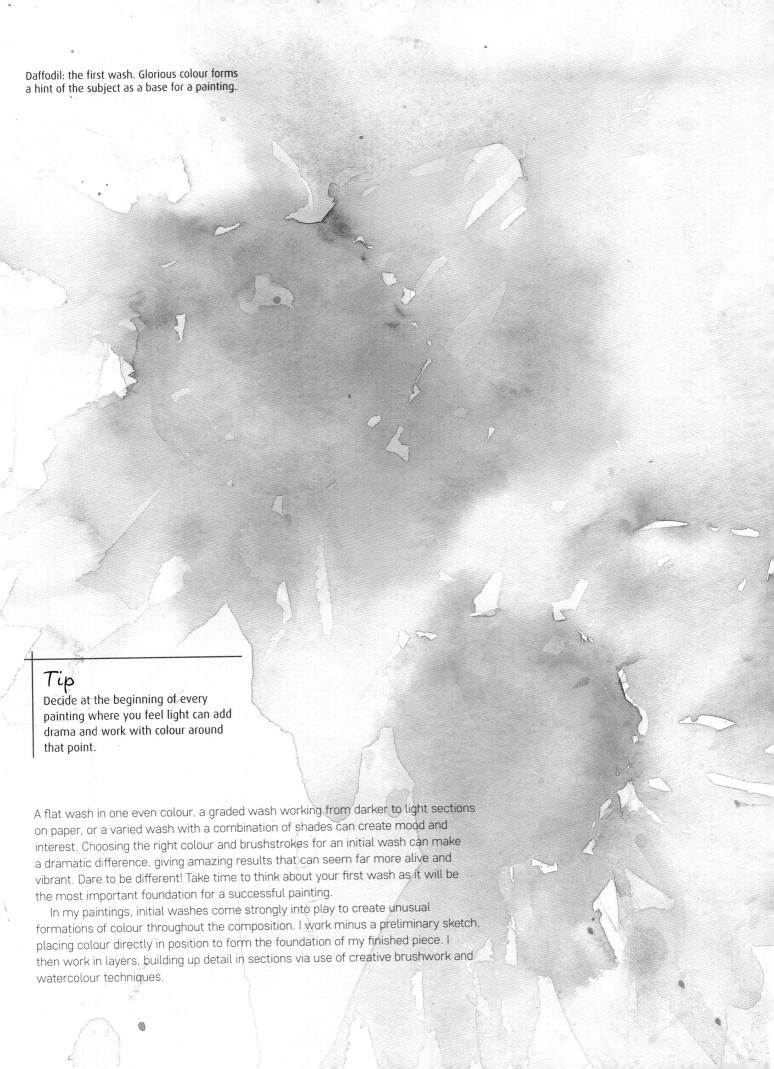

SIMPLIFYING THE USE OF COLOUR

PAINTING WITH JUST A FEW SHADES TO CAPTURE LIGHT

Exercises that aid learning about pigments can lead to terrific paintings that are full of light, life and movement. In order to give the illusion of sunlight, the use of cadmium yellow as the subject colour or as an overall wash is a valuable tool to the artist who wishes to create stunning paintings that sing with the warmth and energy of a sunny day.

If you observe the painting below you will notice that a very limited palette was used. Cadmium yellow formed the main background washes surrounding the centres of the daffodils. Alizarin crimson mixing with the cadmium yellow created a gorgeous orange for the outer rim of the daffodil trumpets, and just a hint of cobalt blue mixed with the cadmium yellow gave depth to the flower centres inside the trumpets. So just three simple primary shades can create a dynamic piece of art.

We often over-complicate our compositions, and by simplifying the use of colour we can obtain beautiful results. Adding too many shades to a painting can make it look busy, fussy or even muddy and dull. This can sometimes detract from the light the artist was originally aiming to achieve.

Keep your colours fresh, clean and exciting if you wish to truly capture light in your work. Also, think about limiting your palette for stunning results that glow with light and life. Colour can sing wonderfully when used in a less complicated way. Watercolour as a medium is fantastic for capturing light. The directional brushwork leading the colour away from the flowers in the painting below adds a superb glow to the finished painting.

Tip

Think about limiting your palette for stunning results that glow with light and life.

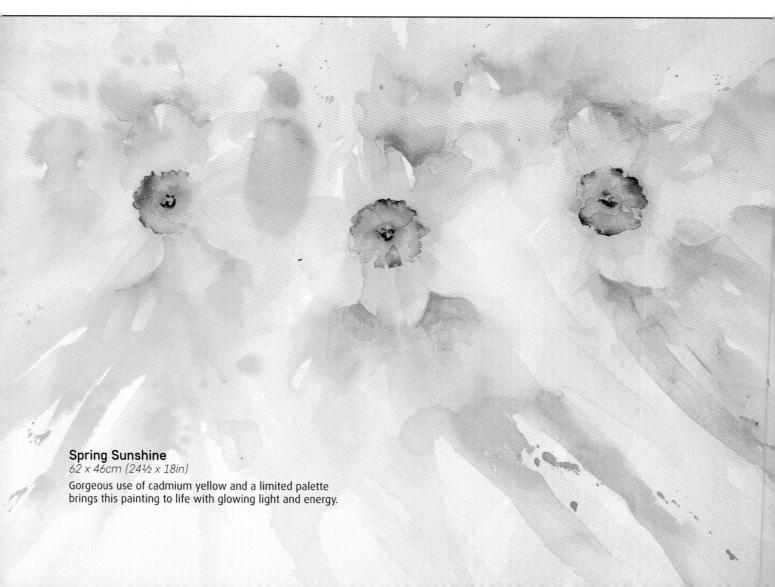

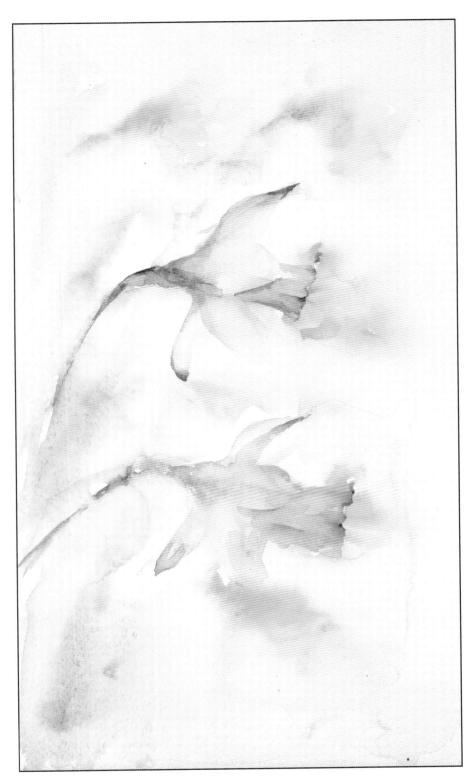

Spring Trumpets 30 x 38cm (11¾ x 15in)

Soft use of colour here adds a very different feel of sunshine. Though retaining a sense of light, the painting itself is far softer, calmer and more peaceful.

Compare the two paintings *Spring Sunshine* and *Spring Trumpets*.

In Spring Trumpets all the flowers are facing in the same direction, and there's a suggestion that they are moving slightly in the breeze. Echoes of colour behind the main flowers create the illusion of sunlit subjects in the distance. The cadmium yellow used here was diluted heavily, hence its paler hue. The greens created by mixing cobalt blue with the cadmium yellow give me a spring green that works perfectly in harmony with my flowers in this piece. When I look at them I feel as though I am seeing rays of sunshine. They have a feel-good factor, and that is exactly how I felt when painting them. Cheerful, happy and light!

These two paintings highlight the way that only a few colours on your palette are needed to capture light in the most effective way. When you look at new subjects, imagine how you could choose just one or two colours to bring them to life, capturing light but in the simplest way. I do believe that to an artist aiming for a loose interpretation in a composition, the word 'simplify' is a vital one. Never overwork!

Tip

Keep your colours fresh, clean and exciting if you wish to truly capture light in your work.

TRANSPARENT LAYERS

The most wonderful quality of watercolour is transparency, which allows you to build up layers that in turn can create amazing effects. This is where learning about individual pigments is so important. Please remember it is vital that your work is dry in between adding each layer or you will find you disturb the pigment in the previous wash. Be patient.

Learning to allow watercolour as a medium to shine with all its fantastic qualities is a skill many watercolourists strive to do. Let's look at a few ways in which pigments can interact with water to create a stunning painting and capture light.

ROSES STUDY

1 Beginning with alizarin crimson, leave white paper to give the light effect of a summer's day. Notice how wonderfully transparent this red shade is. This means it can be used as a layer on top of other colours. It will interact well with other pigments, too.

2 By dropping in cadmium yellow and allowing it to interact with the still-damp alizarin crimson, you will gain warmth and beautiful new shades as the two colours merge. This is a fabulous wet-in-wet technique (see page 66).

3 By 'dancing' with colour on either side of my central subject I can guide pigments to merge and fade as they are painted away from the fabulous starting point. I love seeing through pigments so that the paper is still visible underneath. This transparent quality is characteristic of watercolour, and seeing it in a finished painting is magical.

4 Begin to form the petal edges using a clean, damp size 10 brush. Gently move it in a curved shape where you feel a petal edge should be. This makes the tiny section you are working on lighter, and encourages more transparency in the new lifted section.

Tip

Lifting is a technique in which colour is removed (see page 67). Some artists use tissue to do this but I prefer not to, as it can damage the paper surface. I aim for my paper to look as wonderful when I have finished painting as when I started, so no heavy rubbing away of colour or lifting with tissue for me!

5 As you move outwards, away from the rose centre, the petal edges can become wider and slightly bigger.

6 Once you have a first wash in place for your soft rose shapes, begin to add the green foliage underneath the blooms. Allow the colours to merge at random, connecting the flowers with the leaves to inject a feeling of light and energy into your painting.

7 Drop colour from your flowers into the foliage section to again add harmony and a feeling of connection. At this stage, use your rigger to form a few fine branches, connecting the leaves and flowers and adding balance.

8 Once you are happy with the simplified foliage wash, next find the upper outer edge of your roses. This is created using a negative edge for the outline and then gradually bleeding the colour away from the rose into the background. Use cadmium yellow to create a feeling of sunlight. By leaving some outer edges of the roses as white paper you are also trapping light within each bloom.

9 Think about varying the colour at the top of your roses to add interest. Try breaking up the line of yellow above the three roses with hints of pink too.

10 Please don't feel all leaves in a painting need to be green! By using negative brushwork to form leaves in the white or pink area of the lower wash, you bring yet another illusion of light to your painting.

11 Once the first wash is dry, begin to add detail for the main roses. Start with your rigger brush, adding the centre of each rose. Gradually move away from this point, adding petals that are more defined where needed to tell the story. Add just the right amount of detail but not too much!

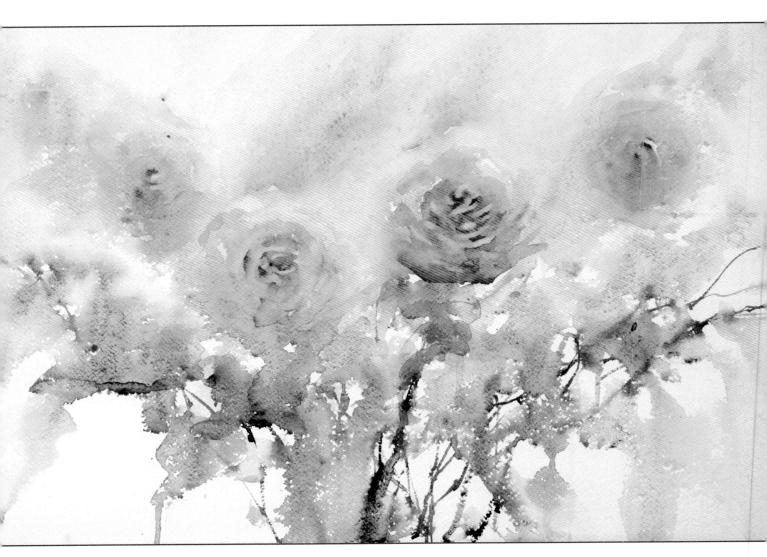

In the finished painting, parts of the roses have been omitted, which adds a sense of intrigue, as well as a strong sense of light hitting the blooms.

This is where personal taste takes over. Some artists like more detail than others, so you need to work out your personal style. Where you stop in a painting will be different for another artist working on a similar subject. But do take your time and practise, because that is the only way you will grow as an artist and become unique.

Some people think that having a loose style means that you can create a painting quickly, but you can spend a long time adding detail to a painting. The first washes are relatively quick, but sometimes you can take days or weeks to finish a beautiful painting. The important part is to enjoy every brushstroke!

Tip

Never race to finish a painting. Remember that the journey is often as beautiful as the destination.

In this pink rose you can see that definition would make the petals look stronger.

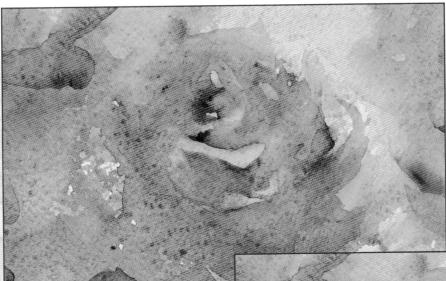

Here, added detail has brought the rose to life.

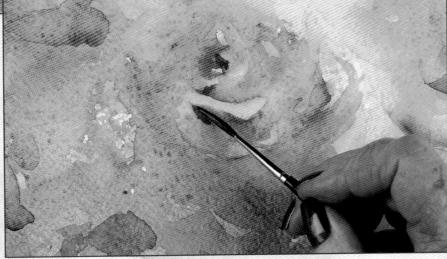

It is the final touches to a painting that make all the difference. They can add light, interest and drama, or take it away.

Choose which is your favourite way to paint. Find out just how much detail you wish to add to your paintings. Do you prefer less detail or more? But most importantly, always strive to keep the light alive by injecting life into your results. Using white paper well, colour, transparent layers or colours merging really can create stunning work full of light, so practise often!

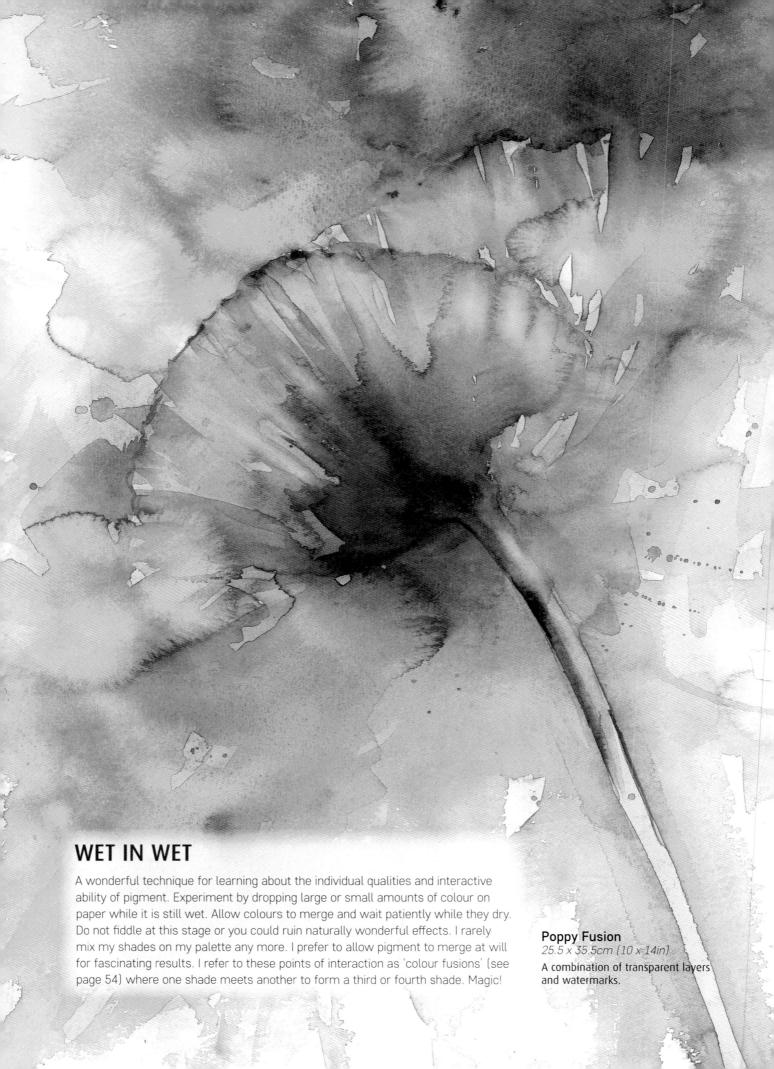

LIFTING

This is a technique I will mention with caution. Lifting with a gentle use of the brush to remove a small amount of colour is a technique that can be used to give the effect of light hitting a subject or simply to add interest. Take care, though, because this technique can also easily kill a painting. Why? The surface of any watercolour paper will only tolerate so much handling. If you are too aggressive you can ruin both the surface and your chances of obtaining a clean result. So please use this technique wisely.

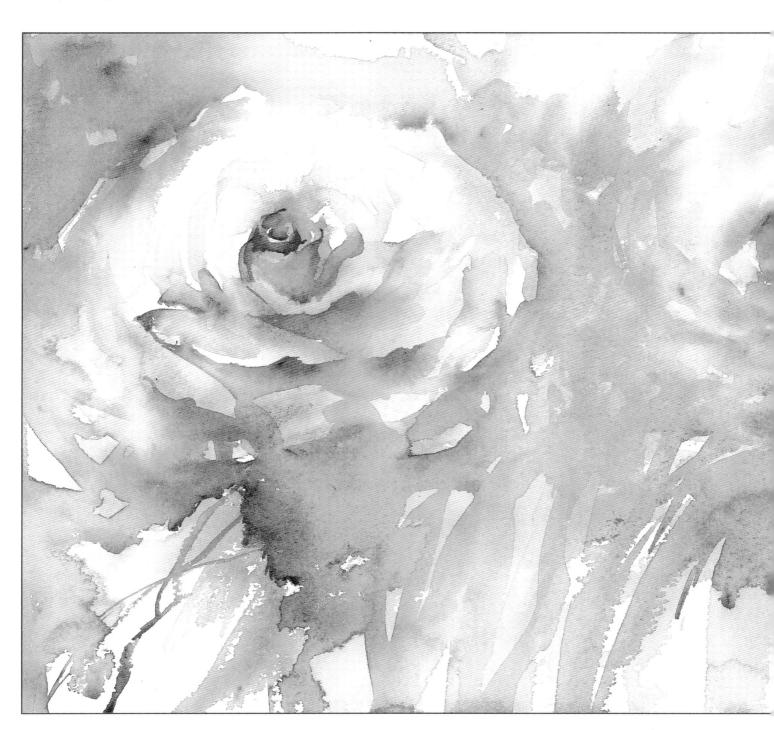

Summer Scent $46 \times 35.5cm \ (18 \times 14in)$ Initial wash of a rose using a gentle lifting technique to form individual petals.

WATERMARKS AND RUNS

I couldn't help but smile when I wrote this section. After years of studying how to create the perfect flat wash minus any hints of watermarks or runs, I now find myself praying for them to occur! It is the imperfections that prove a watercolour is genuine. No other medium has the ability to react on paper in the way watercolour does, so I now celebrate its magical qualities and allow each watermark to shine in a painting. I aim to create them and feel that buzz of excitement when I see a brilliant 'happy accident' whilst eagerly incorporating it into my work.

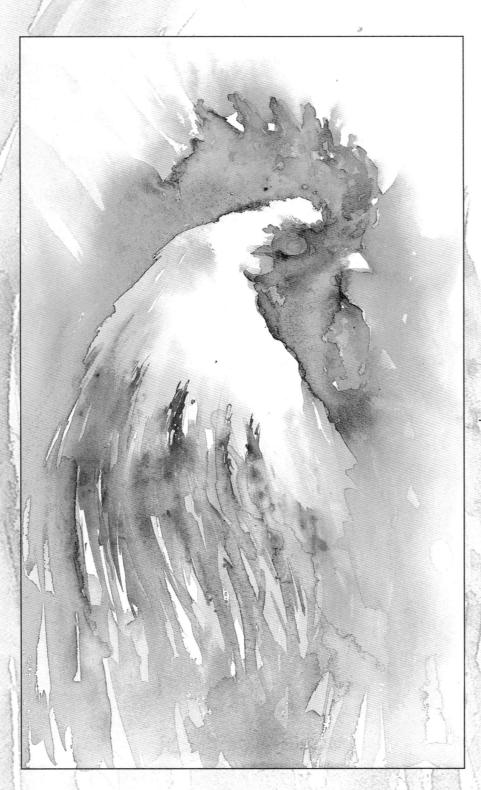

Cockerel: First Wash 20.5 x 30.5cm (8 x 12in)

Creative first wash of a cockerel using a mixed wash of wet in wet, directional brushstrokes and colour fusions. Colour fusions occur where pigment has been allowed to merge on wet paper and form patterns. These are encouraged by a subtle dropping action from the brush in a carefully aimed and directional movement of the arm.

Tip

Work with your paper at an angle to create intricate patterns in your work!

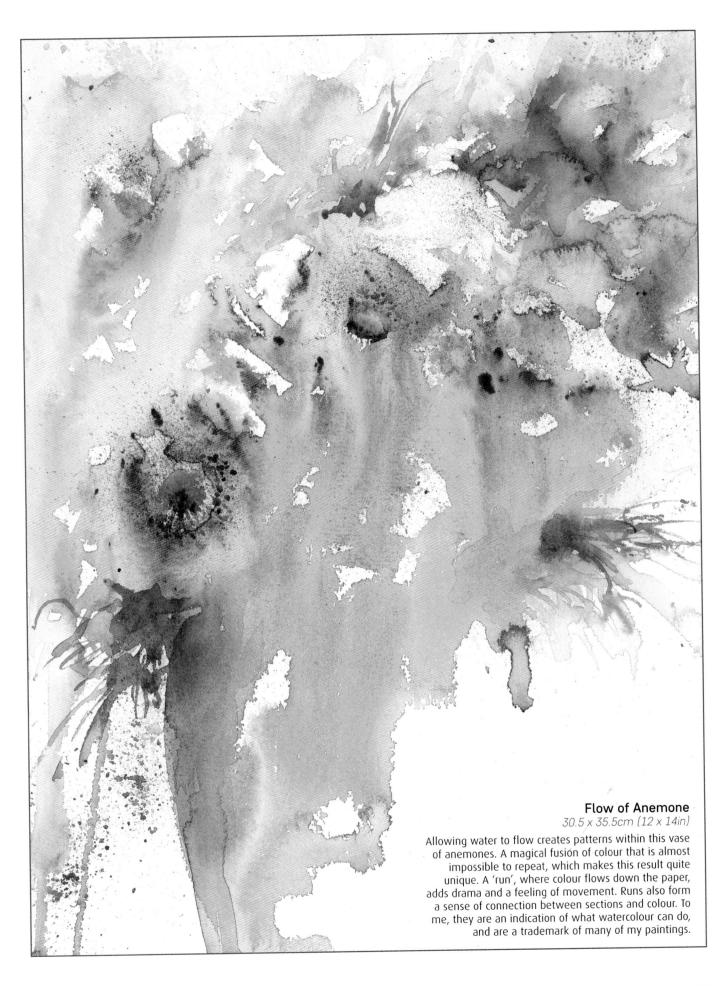

TEXTURE BY SPLATTERING

Simply by splattering colour with a toothbrush you can soften a boring area of a painting and bring it to life. But why stop with the toothbrush? Why not try splattering colour directly from a loaded brush in directional aims at the paper? Even more exciting, while the colour on your paper is still wet, load a brush with clean water and throw that at the paper. Allow it to push pigment out of the way to form amazing fusions of colour and light sections. Have fun experimenting and don't settle for anything other than terrific results in your work.

SALT

I am amazed at how many students seem literally to throw salt on a wash and then expect to achieve miraculous results, when with a little pre-planning along with controlled application you can create such brilliant effects, and place them exactly where you want them. Think about where you place the salt, which direction you apply it and how much you use. I have used salt in the *Sunflower Explosion* below.

Directional splattering of pigment using an old toothbrush.

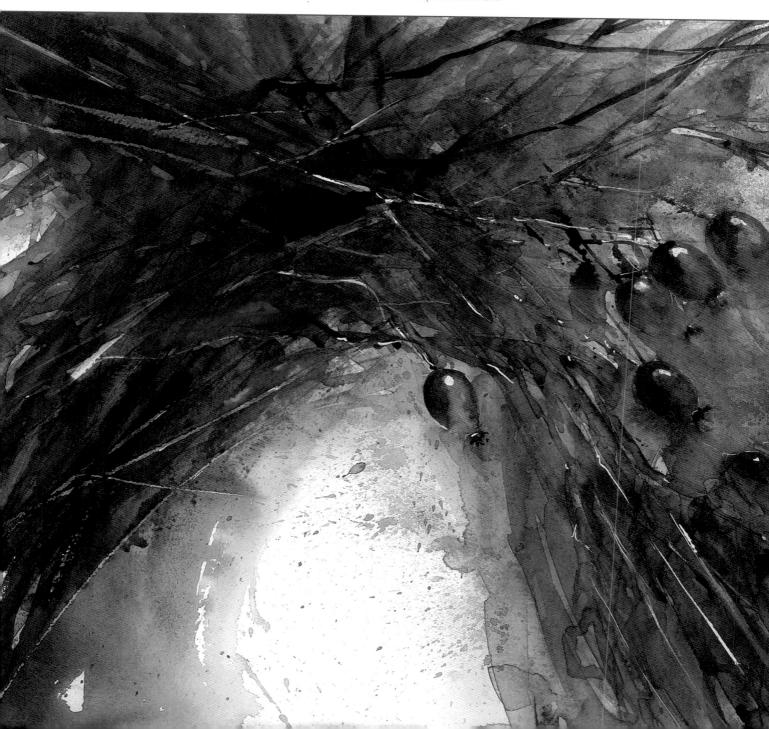

Leaving white paper can create an illusion of light hitting a subject, and so can clever use of texture. In the painting *Sweet Pup* on page 18, the salt technique used in the background echoes the pattern on the subject and adds interest. Where the salt has moved pigment out of the way, it has also added a sense of light in the darker background. Light can be found in all areas of a composition, so use it well.

DIRECTIONAL, VARIED AND INTERESTING BRUSHSTROKES

Think about the way you handle a brush. Use soft, gentle strokes for soft subjects such as fur. Use curved strokes for curved subjects. Think about how many ways you can use your brush, and make each brushstroke count, no matter how small it is.

Sunflower Explosion

71 x 61cm (28 x 24in)

Salt was applied to the initial first wash while it was still slightly damp. I love this result so much I haven't even added further detail.

Autumn Jewels

71 x 56cm (28 x 22in)

Colour selection and directional brushstrokes give a feeling of drama to an otherwise simple scene of twigs and rosehips.

NEGATIVE PAINTING

Simply by painting around a negative space can give a wonderful effect to many subects, as in the painting *Honesty Seed Heads* below and opposite.

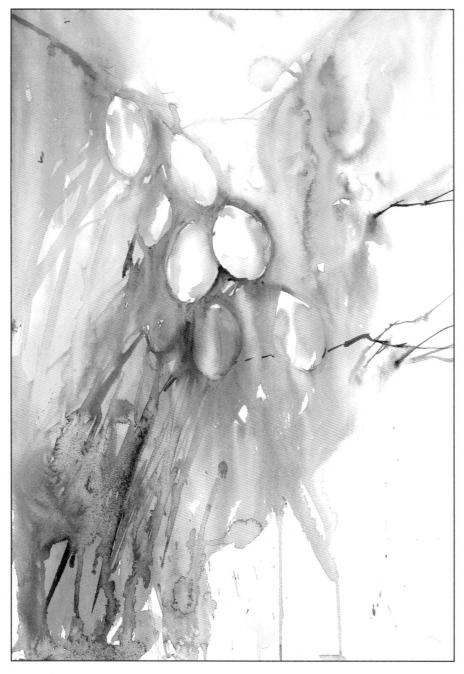

Honesty Seed Heads

56 x 61cm (22 x 24in)

Starting with a varied wash using the negative painting technique, layers of colour were built up gradually and directional brushstrokes used. Final detail was then added to complete the composition.

Here I am creating the shape of the honesty seed head by painting a negative edge. Once this outline has been painted I will move the colour and merge it into the background with my brush by adding either more colour or water next to it. This will soften the hard edge formed.

Autumnal Delights

37 x 57cm (14½ x 22½in)

Adding stems using directional brushstrokes gains a sense of connection throughout the composition. Applying stronger colour in sections gives a feeling of depth and adds interest. Having a dark foundation gives me the opportunity to use white gouache on top when it is completely dry. This helps define the stems in the lower section of the composition. Seed details are the finishing touches that complete this painting.

I enjoyed the experience of working further on my original painting, taking it from a soft, quiet piece to a more dramatic result.

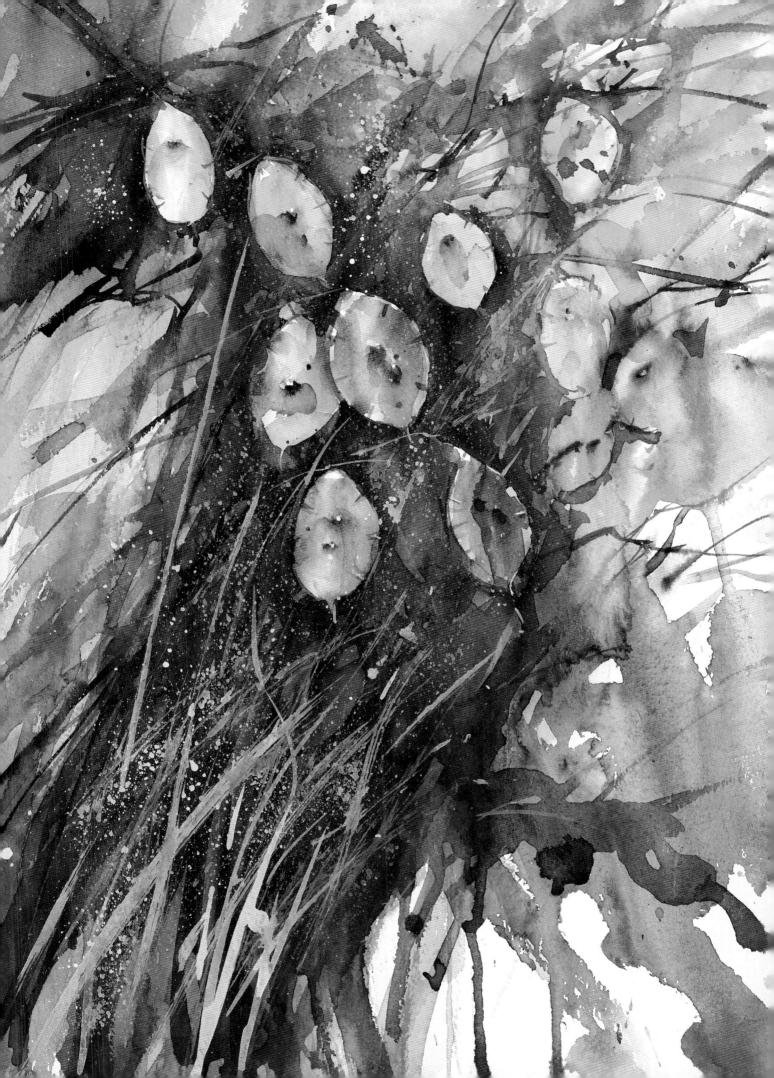

Composition

This is a wonderful area to look into in detail. There are so many books and studies on this subject alone that could easily confuse the most intelligent of us. What is clear, however, is that an interesting composition can make the difference between a poor painting and one that really works.

There is a fine line between following basic guidelines and becoming too predictable. If all artists followed every basic rule on how to create a good composition, our paintings could become similar and almost routine. I like my work to be unique and unusual so I often deliberately break rules on how one should paint. I often choose my favourite part of the subject and then work out how I can make that the sole point of the whole composition. Look at *Teilo*.

Some artists avoid placing a subject in the centre of the paper, or even on a central horizon line. However, with simple tricks and knowledge of how to make a composition work, any subject can be placed anywhere on the paper. It is important to think before you pick up the brush as to how to make each painting successful.

With clever understanding of basic principles, there are ways around every 'golden rule'. Have fun, dare to be different and always aim to create a painting that is unique, well thoughtout beforehand and exciting.

Teilo 66 x 61cm (26 x 24in)

The eye and expression of this gorgeous dog were so beautiful, I made them my focal point. The dog's head is not as you would expect. I worked with colour around this section to make him jump off the paper in an unusual way. The flash of turquoise under his chin makes this really unique and shows off a terrific contrast between the golden shades elsewhere.

Glorious Giant

71 x 61cm (28 x 24in)

This painting of elephants has the subject in the centre of the composition. Energetic brushstrokes accentuate movement, with bold colour contrasts in the right locations adding interest to this exciting scene.

When you have found the perfect subject, decide how to place this with your paper in either landscape or portrait position. Most subjects almost dictate which will be best.

Usually you will know which is the best way to work before you even begin, but next we need to consider how we will make the subject look more appealing. There are so many options that time taken to choose the most interesting is very well spent.

You can place your subject at the side of the composition and simply add colour alongside it to give an illusion of something being there to fill the space.

At The Souq 46 x 38cm (18 x 15in)

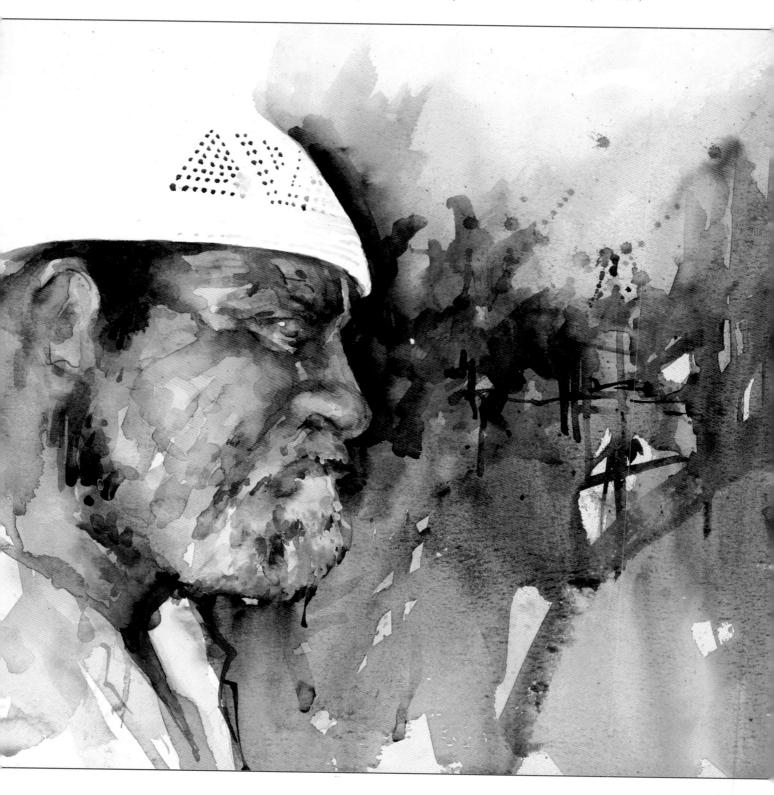

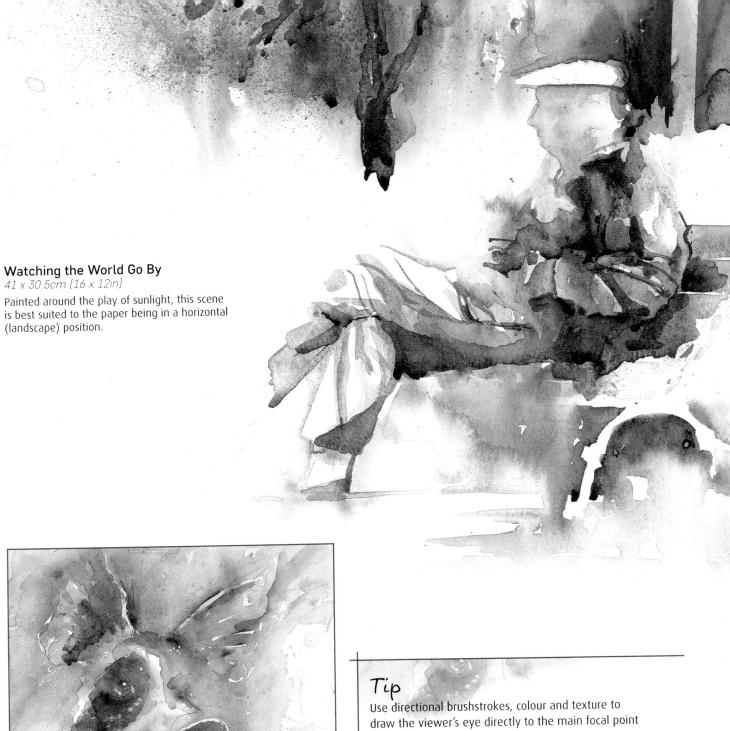

draw the viewer's eye directly to the main focal point in a composition.

Pigging Out 35.5 x 46cm (14 x 18in)

The main subject is in the upper corner of the composition, with colour placement making this idea work successfully. This worked best in portrait format.

Once you have decided what to paint, spend time thinking about ways to make it different and more alive, and always look for the light in every scene you paint. Think before you pick up the brush. Don't race to begin painting. Consider exactly what will be the background and the foreground, and decide on the harmonious colours throughout well before you start. Even deciding about the angles of your brushstrokes will help you produce a successful composition.

Tip

Look at as many compositions by famous artists as you can and try to work out why they work or why they don't appeal to you.

Essence of Spring 51 x 66cm (20 x 26in)

Be imaginative and look at a variety of ways to place your subject that could be unusual and striking. These daffodils show how a curved or circular placement can often create an effective arrangement.

Poppies of Gold 46 x 56cm (18 x 22in)

We can choose to cover the whole paper with colour, with a sense of movement created purely by directional brushstrokes. The focal point in the poppy painting is the main flower in the upper section of the paper, with everything else painted in less detail to draw the viewer's eye to that point. In fact the background is merely

there to showcase the focal point.

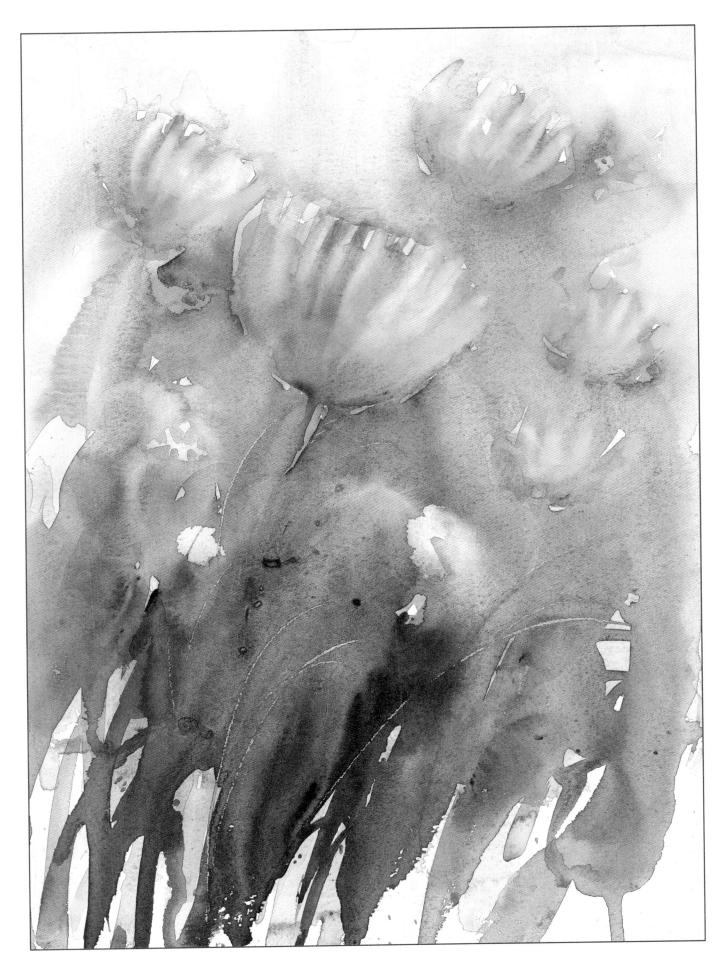

Pulling it all together

As you can see from the previous chapters in this book, there are many ways to capture light and enhance the way in which we portray our favourite subjects. One of mine is cockerels. I love to sit and study their characters, the way they move and the glorious colour of their feathers. They fascinate me as an artist and I never tire of painting them. Each time I pick up my brush to start a new painting of a cockerel, I aim to produce different results. I imagine where the light will be playing on various sections of their heads, feathers and bodies to ensure that all my finished paintings are both refreshingly different and interesting.

Falling in love with a subject has a huge influence on the results we can achieve. It heightens our imagination and enhances our ability to apply colour and play with light. I am convinced that if you try to paint something that doesn't inspire you, that feeling will be reflected in your finished work. Boredom with a subject can kill the light and life in a painting.

Absolutely Fabulous 62 x 46cm (24½ x 18in)

A cockerel created in watercolour with a combination of the salt technique, colour flow, and use of white paper for light and interest.

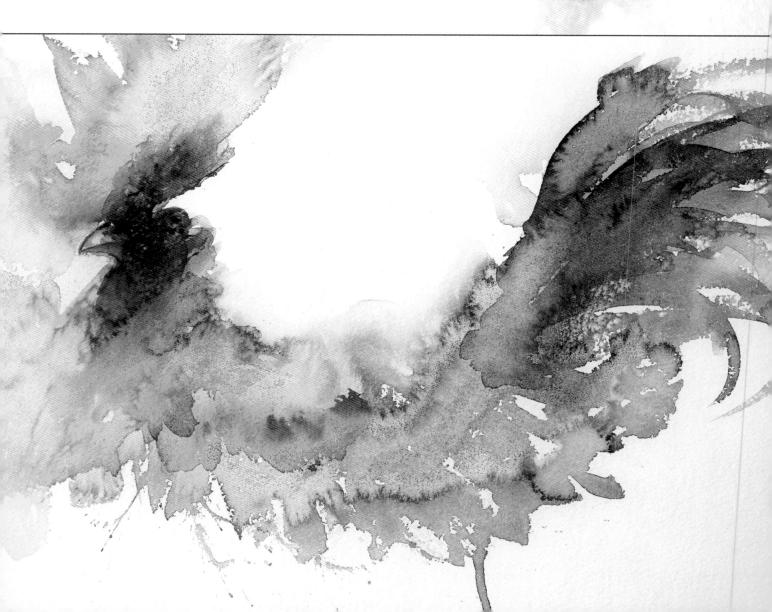

COCKEREL STUDY

Before I attempt to paint a large painting, I often begin with a small study to warm up first. This gives me a chance to observe the details I wish to define and those parts I want to keep more abstract.

I keep the first touches of colour simple, and the first three steps are important so I take my time on these. I decide where the starting point should be placed on the white sheet of paper, then begin.

1 Find your starting point. The whole painting will be formed from this small initial section. Make a small, neat circle of colour using Daniel Smith perylene red.

2 From this first brushwork, you can begin to build up the surrounding area. Work with only one brush at this stage. A size 10 sable, held at an angle, can give you the finest of lines by using just the point of the brush.

3 To paint the wattle below the eye, use sideways, curved brushstrokes.

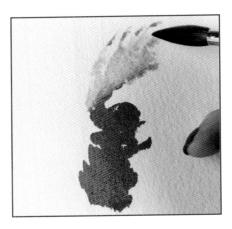

4 Next create the comb of the cockerel. Use a clean, damp brush to move away the still-damp colour line at the top of the head towards the top of the paper.

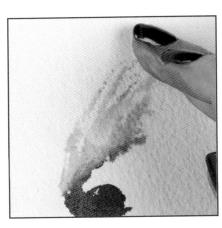

5 Avoid hard lines to give the illusion of movement. Use your fingers to gently brush the colour away.

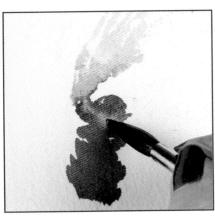

6 Wait until the sheen has started to disappear from your wet pigment before using your clean, damp brush to form a semi-circle for the cheek of the bird.

Tip

I never use tissue or paper to lift colour. This can harm the surface of the watercolour paper and also leave a hard line. A gentle touch with a damp brush is all that is needed for this technique.

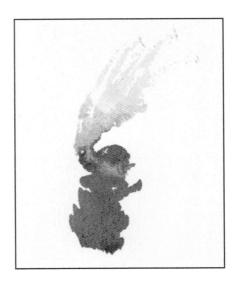

7 The finished cockerel head. Simply placing a curved watermark below where the eye will be creates a subtle change in colour. Practise this technique and discover where else and on which subjects you can use it.

8 Using a rigger brush, continue to mould sections of colour to give a sense of depth and light. I call this technique 'watercolour sculpting'.

9 Find the central line of the beak by observing where it sits relative to the eye (usually below it).

Tip

To make sure the beak is in the right place, create a fine line with heavily diluted colour first. You can then add stronger colour at a later stage, or start again by lifting the first colour application.

10 Form a curved line from the tip of the beak to the head of the cockerel, just below the central line, and allow the colour to flow into this section. This gives you a beautiful and natural-looking shadow on the lower beak.

11 Find the right place for the upper beak to begin. This will usually be just above the eye, or in line with it. Be as accurate as you can with the size and position of the beak.

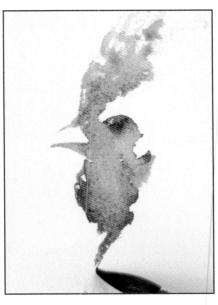

12 To avoid your painting looking boring, add touches of orange to brighten up the red sections. Allow the two colours to merge randomly rather than trying to control them. Deliberately leave white sections to retain a feeling of light in your work.

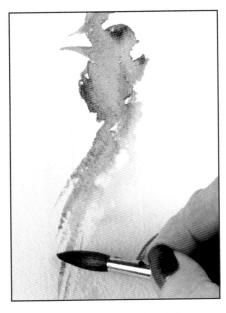

13 Begin to add the body of the cockerel by working away from the head and the starting point. Here I have use a soft, diluted violet but a glowing gold would produce interesting results too.

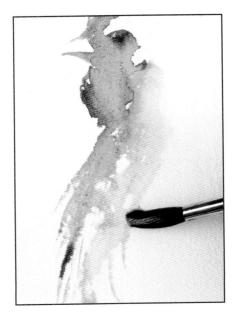

14 Blur the newly added brushwork with a clean, damp brush and allow the colour of the body to connect with the colour of the head.

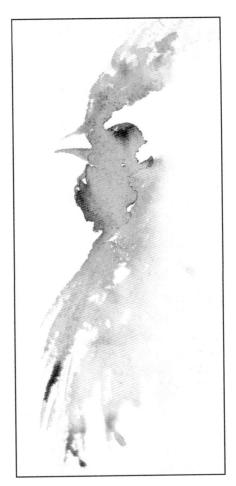

Here is the finished study: a light, fresh approach to painting a cockerel.

In the small painting above you can see the paper through the transparent pigments. This alone captures a feeling of light and life. But what if you wanted to paint a full composition? From this small practice piece you can move on to a more professional painting at a more advanced level.

Of course, you can paint the same cockerel in many colour variations and using a variety of techniques. The cockerel study opposite was painted from a random blob of paint that had dried on a scrap of paper! I saw a cockerel and brought it to life by adding the head to the dark body below. Using our imaginations as artists can lead to brilliant results!

Something to Crow About 17 x 25cm (63/4 x 93/4in)

Making a blob of colour come to life on a scrap of paper.

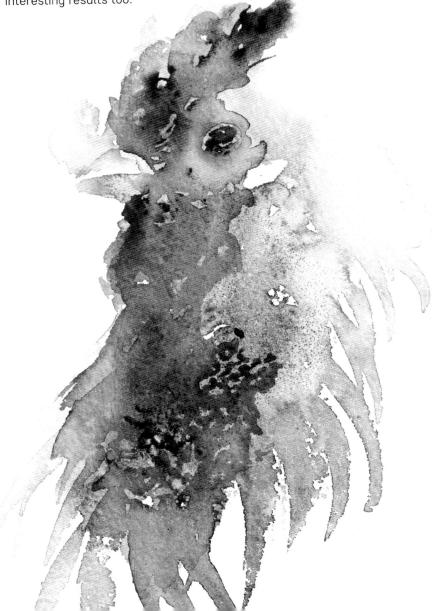

ALTERNATIVE TECHNIQUE FOR TRAPPING THE LIGHT

In the following demonstration, a section on the neck of the cockerel had been left as white paper. I loved how the white neck seemed to shine, so wished to enhance this section further. It was very simple to do.

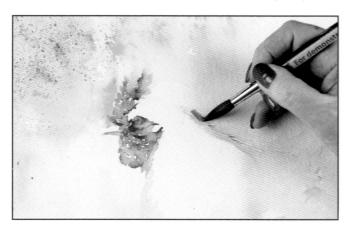

1 By adding a darker background, the white area looks even whiter. Begin by placing a line of gold at the back of the neck.

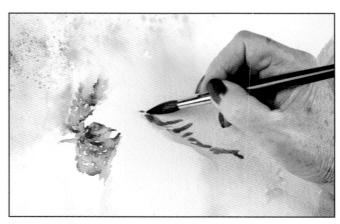

2 Place lines in the form of a directional pattern away from the neck.

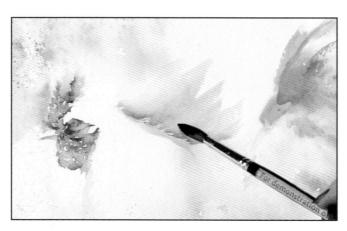

3 Merge this new line of colour away from the subject with side-on brushwork.

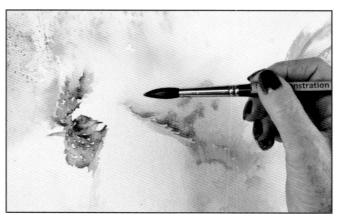

4 Drop pigment randomly into the still-wet background to create interest here.

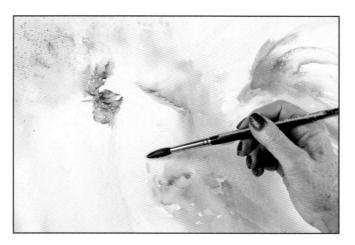

5 Allowing the colour to run into the body creates harmony with the background.

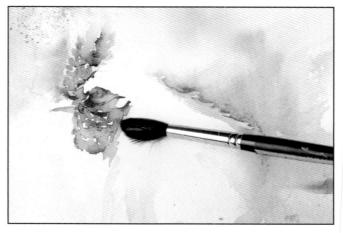

6 Use backward brushstrokes to move the colour up towards the head, but do not lose the central white space of the neck where you have trapped the light.

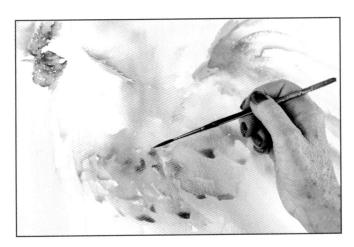

7 With your rigger drop in small amounts of various pigments to form feather patterns where needed.

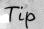

Always stand back from your work at intervals to study it during the creative process. Don't rush to finish a painting. Take time to consider what it needs with each new addition of colour or detail.

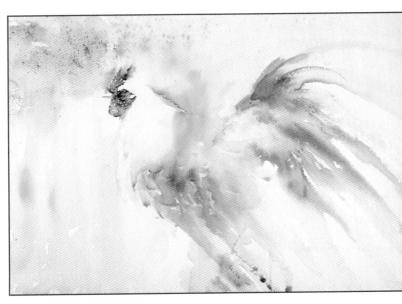

8 At this stage, I would leave the painting to dry. If you continue working you may miss the opportunity to think about the options you have open to you for working further on your painting.

The unfinished cockerel above has a lot of light in it at this stage, but is possibly far too quiet and needs further detail to complete it. The cockerel shown opposite is very different. The line at the back of the neck is missing but the painting works without this added information. The illusion of light flooding over the cockerel has been achieved by the application of water, which has run through all the colours on the body of the bird creating stunning and unique patterns.

Each time we paint we have many options open to us. Experimentation will lead us all to be better artists. I honestly don't think there is a wrong or a right way to paint, but there is your way and that is the most important point.

Paint what makes you happy, and think about how you can give the illusion of light in your work, because this will give it the feel-good factor – just like sunshine hitting our shoulders on a sunny day. Light picks us up and brightens our mood, just as our paintings, or the process of painting, should.

Strutting his Stuff

A different approach to capturing light on the neck of the bird in another cockerel painting.

BAD HARE DAY

I love painting animals and one of my favourite subjects to paint are hares. My main focus of this demonstration is to show you how painting an eye beautifully can be the start of a fantastic painting. The eye is the window to the soul, so if it isn't right, the painting will not look as terrific as it could when it is finished.

Take a new sheet of white paper and think about how the whole animal will sit on it when the painting is complete. How large will your hare be? This is an important question as you need to know how big to paint the eye and where to position it on the paper as your starting point. You need to leave enough room around it to paint the whole animal. Once you have found your starting point on the paper, you can begin.

Tip

When painting animals I follow directional hair patterns, allowing them to guide all my decisions on how to hold or move the brush. I can also drop in darker colour for impact and variety as I begin to build up my animal painting.

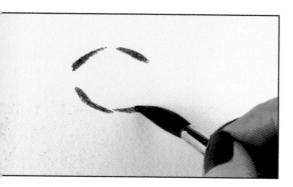

1 Study the shape of the eye carefully before painting the outline. Use the colour of the eye for this outer edge. I am working with quinacridone gold and using a size 10 brush.

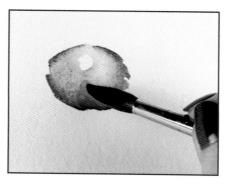

2 Leaving a small circular section white for the highlight of the eye, carefully work around it by filling in the eye colour. Use semi-circular brushstrokes in this area.

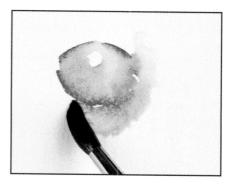

3 I find a lot of artists paint eyes and then the face of a subject, without connecting the two. This can lead to wooden, lifeless results. I form harmony by drawing the colour of my eye into the surrounding area. This can act as a base to further colour addition in the next layers and is very effective.

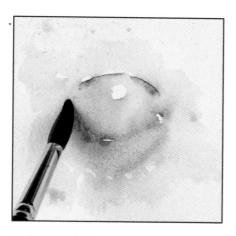

4 The result is a clearly defined eye with soft, matching colour surrounding it.

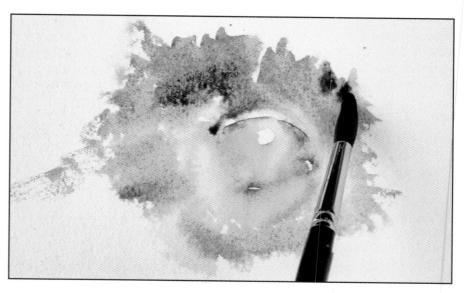

5 Working away from the eye, begin to change the direction of your brushstrokes to give the illusion of fur.

6 I love stroking animals in real life, and have discovered that by 'stroking' pigment I can gain wonderful, soft fur effects. So on the outer edge of the hare, stroke the pigment with your thumb or finger to move it into the white space surrounding the subject.

7 The face of the hare is gently appearing.

8 Once your first wash is in place as an initial base for your subject, add stronger colour in layers to build up your painting. Simply repeat the first stage but with warmer shades.

To add texture and break up the solid outline of your subject, use a toothbrush to splatter the colour of your subject into the white paper background. This is a very effective technique.

9 Change the angle of the toothbrush and splatter colour from different directions throughout the painting. Under the ear, for example, splatter towards the lower corner to fill the white space with an appropriate directional application of colour.

10 At this stage the painting needs definition. Add the iris to the eye, but be very careful not to lose the white highlight. Add a fine outline to the eye using your rigger brush.

Tip

You can change the colour of the eye or the fur. Just because the subject is brown in real life there is no reason why you can't paint a blue or purple hare. Dare to be unique!

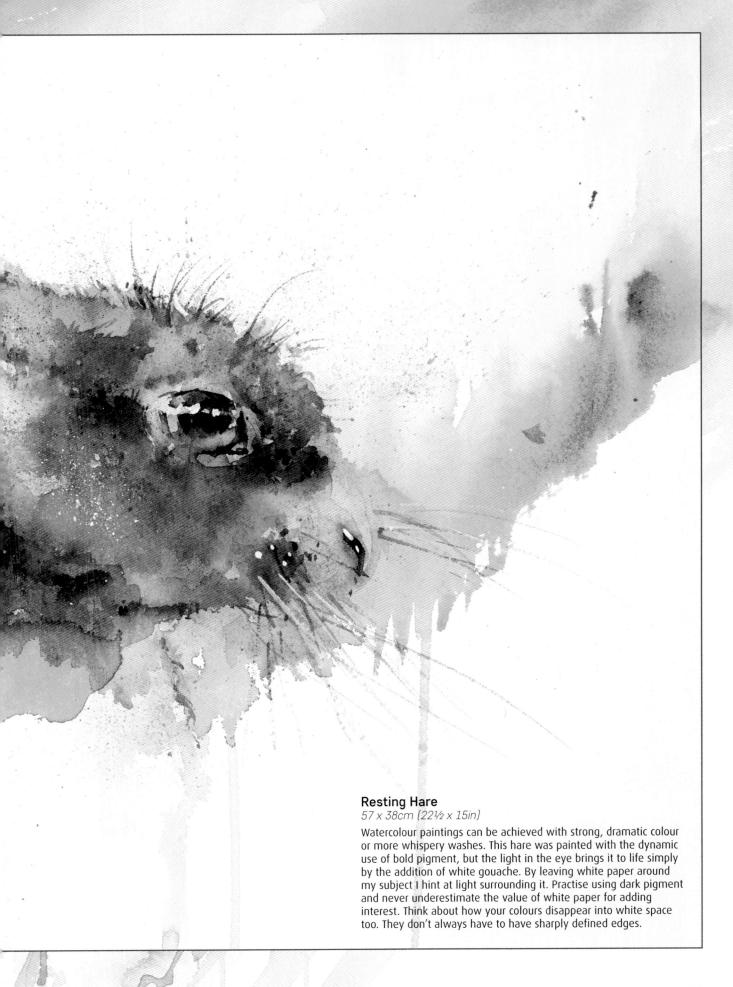

KEEPING IT SIMPLE

Simple compositions are pleasing to the eye, and in this demonstration a good sky and a fabulous foreground will help inject life and atmosphere into your sea scene.

PLAIN SAILING

Like life, art isn't all plain sailing. Everyone, even the most masterful of professionals, has off days. Trust me, I do too! But what is vital to me is that I enjoy the creative process. If I don't, there is no pleasure in painting. And on a more personal note I am not a great sailor, although my husband is. He loves sailing, but at top speed, which is when my face goes green. Because of this, most of my sailing paintings include a lot of green in them!

Tip

You can choose any colour for the sky. Try stunning reds or golds, or dark blue for a stormy sky.

1 Start by placing your paper at an angle and applying colour to the top right corner. Encourage this colour to flow diagonally across the paper to the lower left corner. Leaving white sections will act as an illusion of clouds and light breaking through.

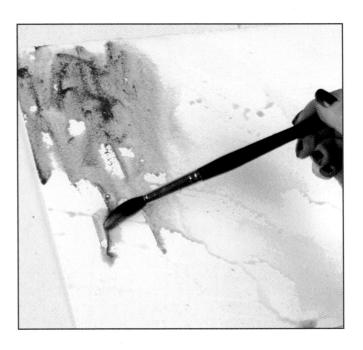

2 Now turn your paper sideways and begin to paint the sea in the foreground. Apply the colour so that it can flow downwards, across your painting. I have used Daniel Smith cascade green.

3 Encourage the green pigment to flow downwards, adding more pigment as needed. Leave white paper to give an impression of light hitting the water.

4 Adding cadmium yellow and allowing it to merge with your green shade will add a feeling of sunshine to the scene.

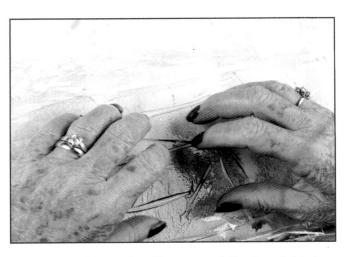

5 While the pigment is still wet, carefully place folded plastic wrap (or cling film) on the surface to form patterns that will give the illusion of waves.

6 Deliberately vary the sizes of the patterns to add interest to you sea scene. You can see what is happening with the pigments at this stage, so don't be afraid to move the plastic wrap to create the patterns you want.

7 When you are happy with your results, leave the plastic wrap in place and allow the first wash to dry.

8 Begin to paint the sailing boat. Think about where you wish your boat to be in the composition, and start by painting in the mast. Use a piece of straight-edged paper or card to paint a fine line with your rigger brush.

9 Now paint the outer edge of the sail.

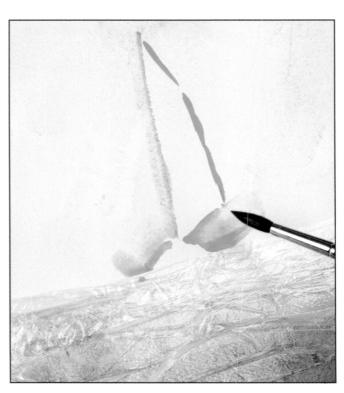

10 Add the boat quickly in order to merge the outline colour into the background before it dries.

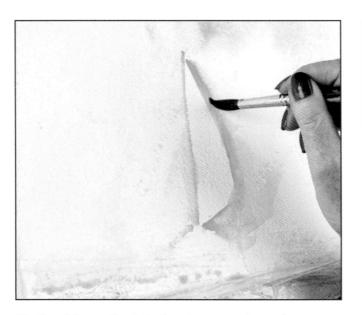

11 Blend the outline into the sky area using a clean, damp brush.

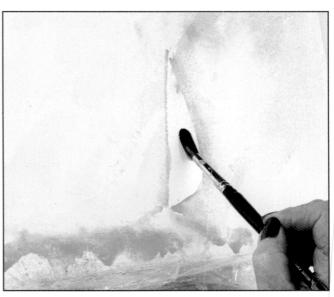

12 Merge the sky into the sail in places. This prevents the boat from looking like a cardboard cut-out, detached from its surroundings. Your painting so far should appear soft and atmospheric, with the sky and sail full of light. Leave the painting to dry.

Tip

Try to merge your subjects with their backgrounds as much as possible. This helps to create harmony within your compositions and gives them energy, life and a feeling of light.

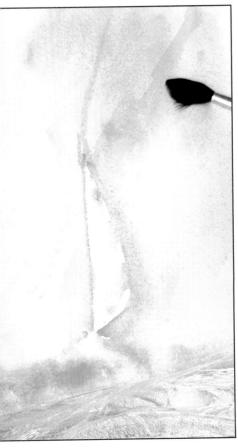

13 To add drama, place a layer of cadmium yellow glaze across the centre of your painting. Avoid the sail and just lay the wash on the background. This technique can be used to create many wonderful effects over existing dry watercolour.

Layering a glaze of a cool shade over a painting that is too warm, or a warm shade over one that is too cool, can alter the mood of a piece dramatically.

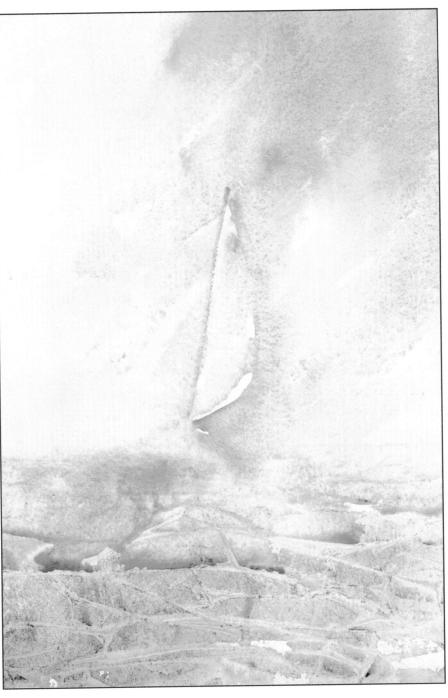

14 Allow the paint to dry and remove the plastic wrap. Now you can decide whether to work further on it or not. If you like your painting at this stage there is no need to add any other details. But, as with all works in progress, you have choices. You could, for example, add mountains in the distance, or other sailing boats.

This demonstration can provide the inspiration for many gorgeous watercolours. Start looking at sky and sea formations. Study scenes and bring them to life, always capturing the light to bring extra excitement to your work.

Have fun experimenting, and never think there is only one way to paint a subject. All that is needed is a little thought and enthusiasm and your painting will be unique. See the light and paint!

Sailing By 28 x 36cm (11 x 141/4in)

The sailing scene on the previous page has grown with the addition of lines for rigging, hints of mountains in the distance and touches of colour where needed to bring the composition to life. Note the directional lines changing from horizontal in the foreground waves of the sea to diagonal colour application across the sail. These subtle effects are eye catching and create interest. Thought given to where I leave the white paper helps me gain a sense of light in the scene.

Tip

Think about how careful use of directional lines can draw the viewer's eye to the focal point in a finished painting.

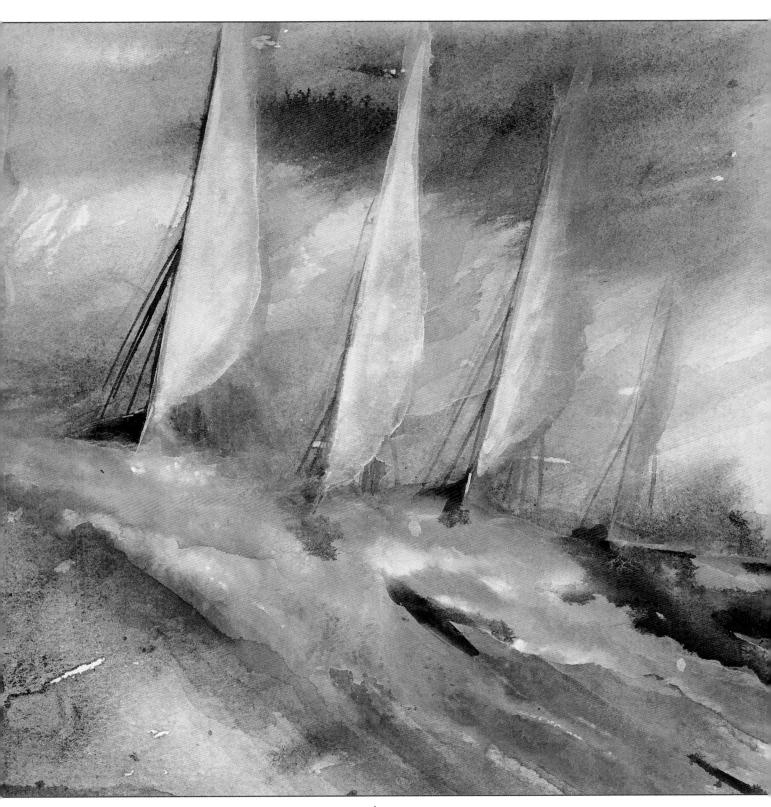

Sunset Sails 28 x 20cm (11 x 73/4in)

A simple suggestion of sails at sunset. The use of warm shades gives the illusion of a golden glow in the distance.

Tip
Observe colour in everything you see and notice how light plays a huge part in bringing scenes and subjects to life.

Are you desperate now to create your own beautiful, finished painting? So am I, so let's race into the step-by-step demonstrations and see how to pull all these ideas together.

We have studied colour, light, techniques and composition. Now it is time to see how they all come into play in a painting, but please make sure you fully understand all the previous suggestions before you pick up your brush in order to gain the maximum enjoyment out of each demonstration. And just one more tip: try smiling while you work. You would not believe the difference it makes to your results!

A bored artist produces boring paintings and we are aiming for results that positively glow with light, seem to have a sense of movement and life in them and are all absolutely unique!

Before you begin painting, lay out the colours you need around the edge of your palette. Select your mixes and try them out on a piece of scrap paper. Try to visualise the finished painting before you start, and decide where the focal point will be; all of the brushstrokes and colour work will flow towards that point. Preparation is the key to a successful painting.

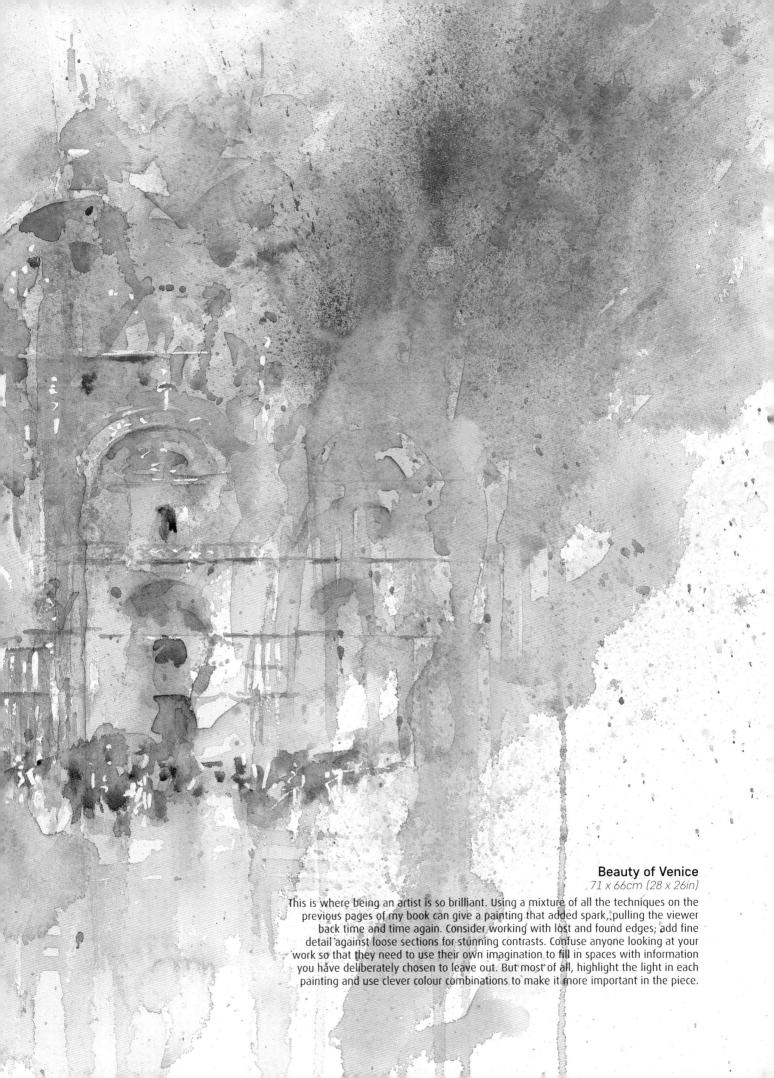

HONESTY

This simple project, whose subject is honesty seed heads, otherwise known as the silver dollar plant, begins with painting around negative shapes. You will learn how to allow colours to flow and interact, leave sections affected by light, use colour contrasts to add impact, and eventually produce a soft result in watercolour. Begin by choosing the colours you wish to use.

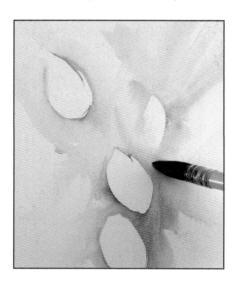

1 Begin with the wash brush. Dampen the brush and load it with dilute alizarin crimson. Paint around the three main seed heads. This area of the paper will remain dry. Before the pigment dries, soften the edges with water and pull away in different directions – this will create water tracks for the colour to run into. Bring some cadmium orange into the water tracks towards the top of the painting to represent sunlight. Create colour fusions by allowing the colours to mix on the paper.

YOU WILL NEED

- 300gsm (140lb) rough watercolour paper, approximately 38 x 56cm (15 x 22in)
- Paintbrushes: size 8 squirrel pointed wash brush, and size 3 (fine rigger) and size 10 Kolinsky sable watercolour brushes
- · Painting knife
- · Toothbrush
- · Palette
- Watercolour paints: perylene maroon, French ultramarine, quinacridone gold, cadmium orange, alizarin crimson, Winsor violet, burnt umber
- · Designer's white gouache

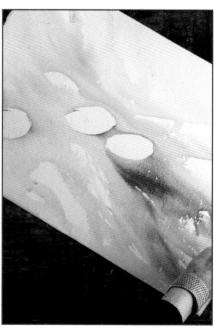

2 Bring in some cooler colours – purple and blue – in the bottom left of the painting and define the edges of the seed heads. Don't be afraid to introduce some intense colour – Winsor violet to the lower corner will bring a feeling of depth to the shadows here, and work with quinacridone gold in the opposite corner (top right) for a wonderful contrast of vibrant shades. All the shades will merge and interact as the painting develops.

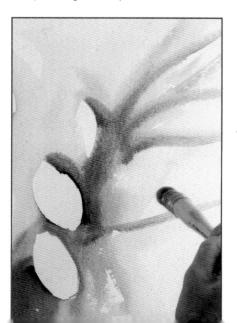

Tip

Change the angle of the paper to control the direction in which the paint runs.

3 Continue to intensify the colours. Use alizarin crimson to bring in the twigs in the top right part of the picture. This red will interact with the damp colours already on the paper.

Tip

Colours will always dry paler, so they can be quite strong initially.

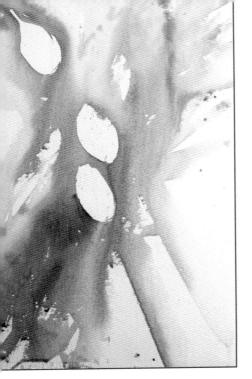

4 Allow the alizarin crimson to flow downwards to the right. Add some splatters of colour using the size 10 brush – red top right and cadmium orange bottom left. Turn the paper to force the paint to run and create glorious colour fusions. The first wash is now complete and you are ready to move on to the next layer.

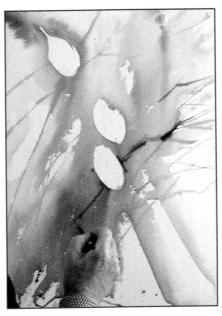

5 Using the smallest brush, start to add the fine twigs. Use burnt umber. Try to obtain a sense of flow through the painting. Stop every now and then to allow the colours to fuse.

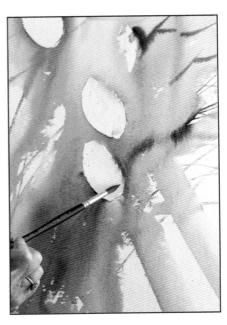

6 With the size 10 brush, bleed the background colour into each of the seed heads. Do this by wetting the inside of the seed head with a damp brush, and just touching the edge of the shape with the brush so that the colour runs into it. Allow the colour fusions to develop before continuing with the painting.

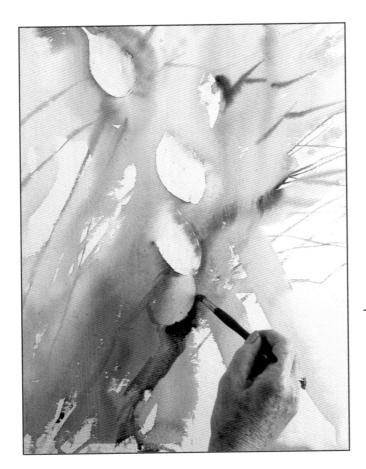

7 Use your imagination to develop the painting and build up the layers. Bring in some cadmium orange to define the edges of the main seed heads, and to outline more seed head 'ghosts' in the background. Lay on more red and purple, allowing colours to run and blend into each other.

Tip

Try to gain a sense of freedom as you work – bring in light where you want light, and dark where you want dark.

8 Flick your painting with water and splatter with colour, building up the painting to create diagonal movement across the paper. Work carefully around the main focal point so as not to detract from it. Bring in more colour to define the 'ghosts' and to accentuate the dark area in the lower left-hand corner. Add more stems to this area of the painting – draw some into the paint using the tip of the painting knife.

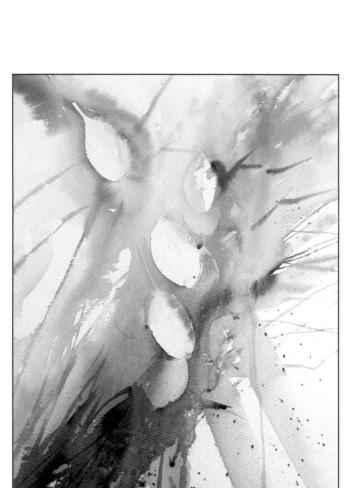

Move to the top right of the painting and bring in strong orange colours to accentuate the light area. Continue to define the seed heads, softening the edges as you work. Splatter the lower right of the painting with purple and the lower left with plain water to create bursts of colour.

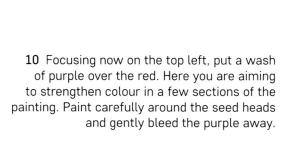

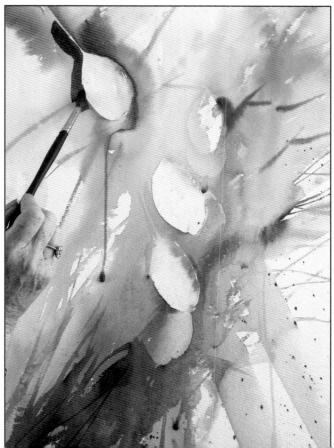

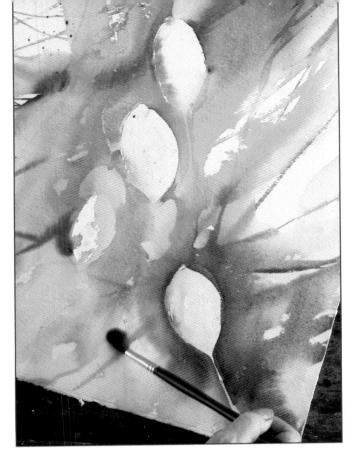

11 Introduce some French ultramarine into the top left corner, and use it to define more 'ghosts'. Turn the painting upside down to bleed out the colour. Bring more purple into the top of the painting to create harmony. Keep moving and adding drama to each section.

12 Turn the painting back up the right way and introduce an arch of blue on the left. Hold the brush at the end and use your whole arm to bring in more twigs.

13 Continue to build up the painting – by now, it should be painting itself! Add more twigs where needed, and lay washes inside the seed heads as before. Stand back and observe your painting before continuing with the next layer.

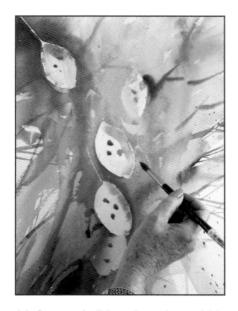

14 Start to build up the colour within the seed heads – just a little, to give them form and depth. Bring in some dots of burnt umber mixed with a little orange to represent the seeds. Circle each seed with water to trap the light (see page 54).

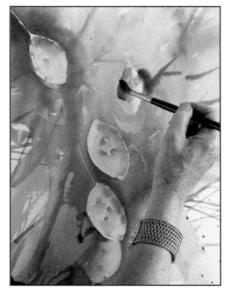

15 Soften the seed heads and use the tip of the brush to create a circle of light around each seed. Accentuate the background 'ghosts' where necessary. Reassess your painting and decide which areas need further definition. All the elements of the painting are now in place – you now need to start pulling it together. Work only on the areas you are not happy with – leave those you like alone.

Tip

As a general rule, make each corner of your painting different.

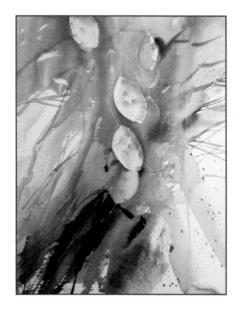

16 Mix some French ultramarine and burnt umber and introduce some dark twigs, starting in the lower left corner. Carefully go round the edges of the seed heads and soften the background where necessary. Add a few connecting strokes to draw the painting together and create harmony.

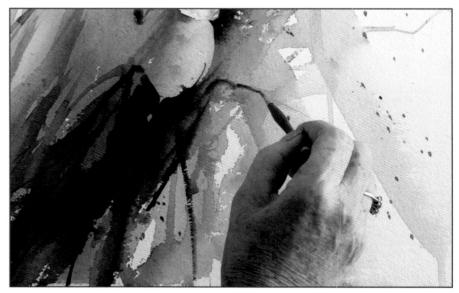

17 Bring in some more twigs bottom left using red, and define the seeds within the main seed head using maroon (but avoid overworking). Change to the size 3 (fine rigger) brush and, using dry brushwork, introduce contrast by adding dark, thin lines here and there. Place fine lines around parts of the seed heads to define their base.

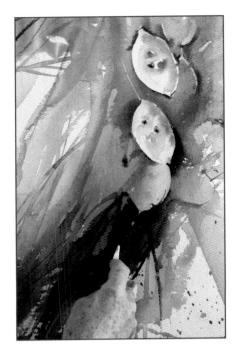

18 Scrape out some light twigs in the bottom right of the picture using the tip of the painting knife, then reassess your painting.

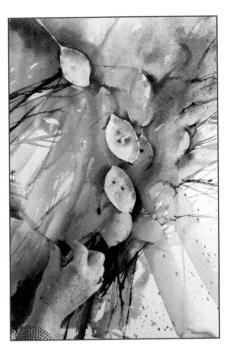

TipAvoid repetition and boring results!

19 Further define some of the darker twigs using red and purple, then splatter into the painting using the toothbrush. Think carefully about where the paint is going, and avoid splattering in one direction only. Use red and purple over the orange areas, red on the purple, and dark purple on the light purple for contrast.

Tip

If you place a light colour behind a stronger version of the same one, the light colour will appear further away in the distance.

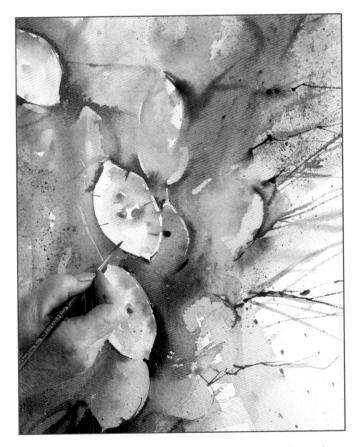

20 Using the smallest brush and purple paint, place six tiny lines around the inner edges of the main seed heads. Add a few to the 'ghosts' as well – not too many; just enough to show what they are.

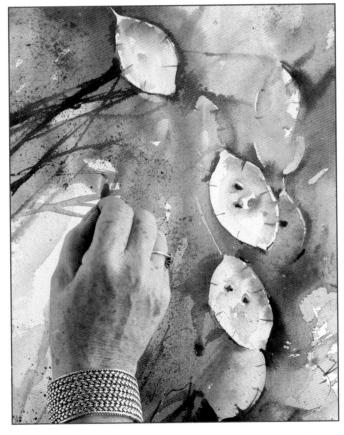

21 Strengthen the colours within the two main seed heads, avoiding overworking, and add some more thin lines here and there to make the painting more realistic and bring it to life.

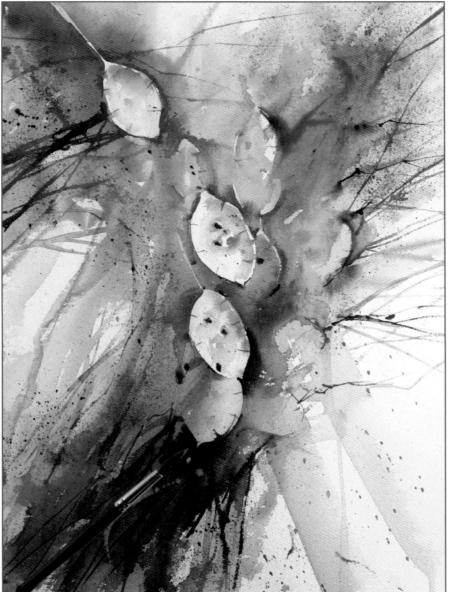

22 For more life and movement, use the larger brush to add directional splatters – purple top right and orange lower left – until you are happy with

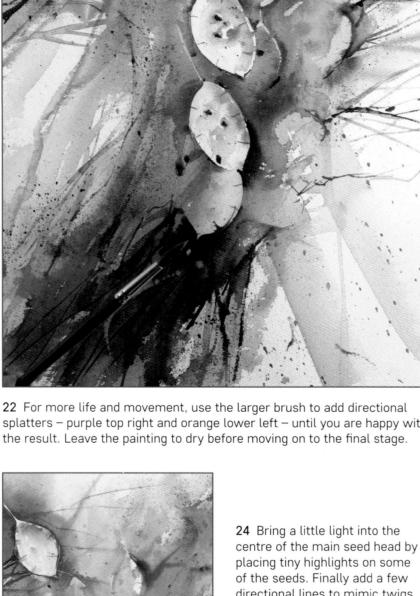

directional lines to mimic twigs that are in bright sunlight.

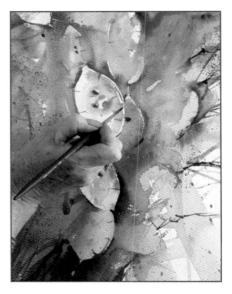

23 Once the painting is dry, add a touch of gouache (it's important not to add too much). Use the size 3 brush and add it here and there to give a feeling of movement and depth to the picture and inject it with life. Use it also to correct the shapes of the main elements if necessary, but avoid following all the lines too closely.

Be careful not to add too much gouache - the best results are obtained when the highlights are subtle and delicately placed.

A fusion of vibrant colour of varying intensity, along with directional brushstrokes, add impact and drama to a very simple subject.

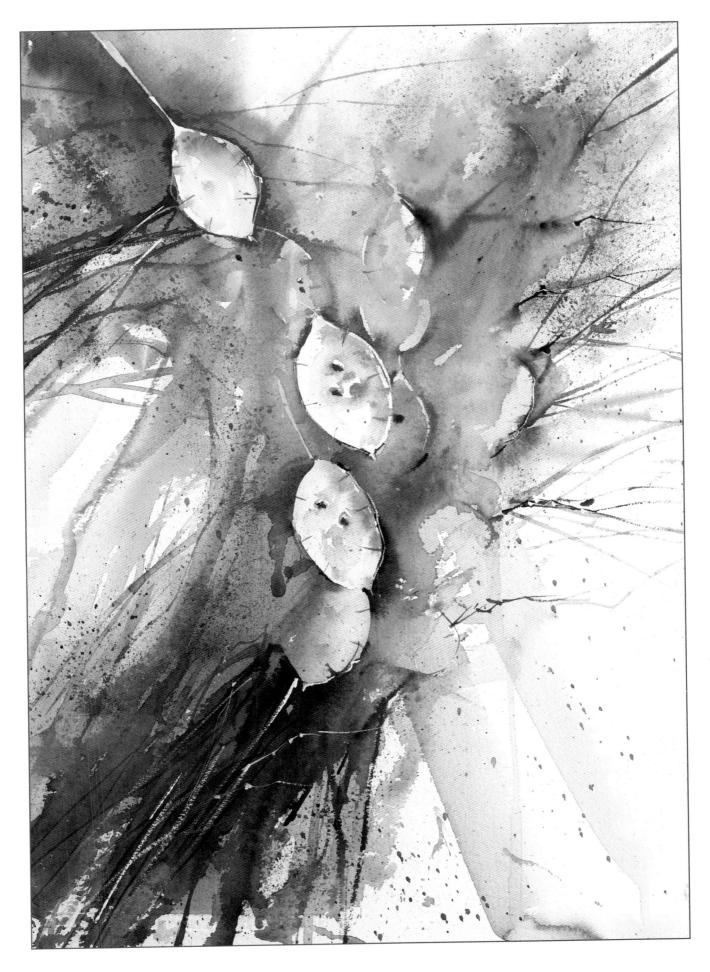

ADDING DRAMA

You can add drama by working further on your painting with darker colour, possibly linking each seed head or by connecting each section with further directional lines for stems and branches.

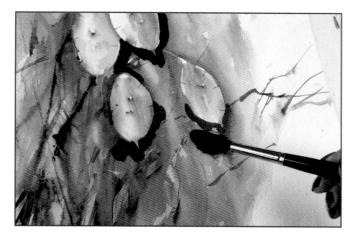

1 Creating darker outlines enhances the existing white and lighter sections.

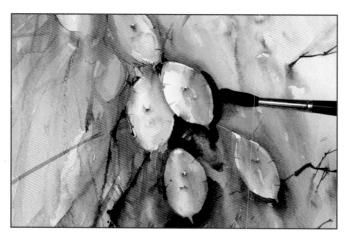

2 Soften these new outlines using a clean, damp brush as necessary so that they merge with the background. This will allow the seed heads to sit within the painting rather than being left as well-defined shapes, which could look too prominent when your painting is dry.

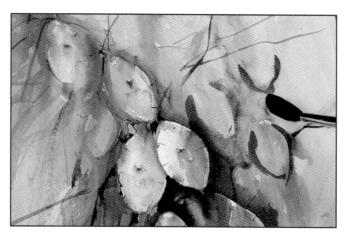

3 By varying the outline colour of the seed heads in sections of the painting, the final effect can be even more fascinating.

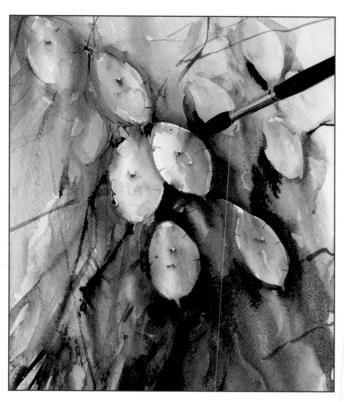

4 You can create new seed heads within the first wash and continually add to your painting. Connect sections by either lines or colour placement. These are personal choices and will make your painting more unique. Always aim to be original in your art.

Tip

I believe that variety is the spice of life, and so it is with my art. I vary colour throughout a composition wherever I feel it works. The more you practise, the more instinctive your colour placement will become.

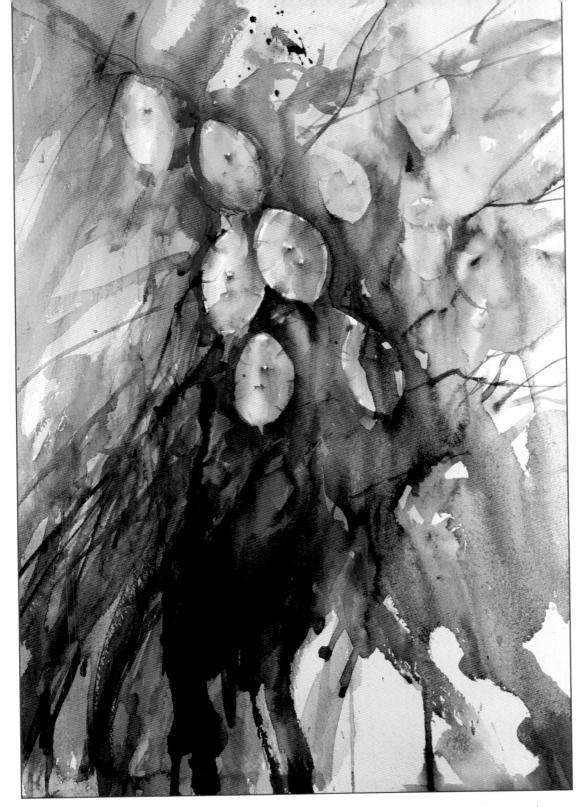

There comes a point in a painting when you need to stop and observe, and decide whether to work further on a painting or leave it as it is.

Not all paintings need to be framed masterpieces. When we are learning or experimenting, there is great value in simply having fun with a piece, enjoying the use of colour and technique. Bear in mind that once the joy of working on a painting has disappeared there is no point carrying on with it as the experience will not be satisfying or rewarding. When you feel like this, start something new rather than labouring over something that just doesn't feel right. But if it feels fantastic and you are happy that it is working, continue!

Do try to stop long before you feel a painting is complete. It is often the last few brushstrokes that kill a painting with no hope of recovering it to become a completed piece of work. Avoid overworking, and keep alive the joy of creating each time you pick up a brush.

CELEBRATION OF COLOUR

Once you have mastered the basic foundation in this simple landscape, you can work on further scenes making them as complex or as simple as you wish. Choose colours to portray the mood, atmosphere and season in either an abstract or more realistic style.

As before, begin by laying out the colours in your palette, and try out your mixes on a scrap piece of paper before placing them on your painting.

1 Working with the paper at an angle, use the wash brush. Begin by laying in tracks of clean water across the paper flowing top left to bottom right. Create runs using diluted orange pigment. Keep the lower left of the painting 'quiet', as used in a 'whisper' of colour (see page 33).

YOU WILL NEED

- 300gsm (140lb) rough watercolour paper, 56 x 38cm (22 x 15in)
- Paintbrushes: size 8 squirrel pointed wash brush, and size 3 (fine rigger) and size 10 Kolinsky sable watercolour brushes
- · Painting knife
- · Palette
- · Ruler or card
- · Toothbrush
- · Salt
- Watercolour paints: perylene maroon, quinacridone gold, cadmium orange, alizarin crimson, Winsor violet, cobalt turquoise
- · Designer's white gouache

2 Splatter in some alizarin crimson and tilt the paper to create bold runs.

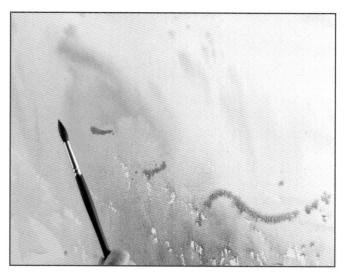

3 Change to the size 10 brush and splatter in some orange, turquoise and perylene maroon at the bottom of the picture. Turn the paper upside down to direct the colour up towards the top of the painting. The aim is to gain a sense of darker colours in the foreground and lighter colours in the background.

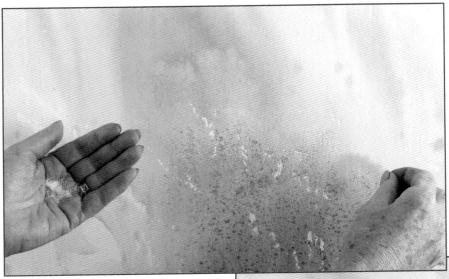

5 Sprinkle on some salt, aiming it directionally from the bottom to the top of the painting. This technique adds texture to the foreground.

6 Continue to splatter on colour to build up the initial wash and create atmosphere. Use gold, a little purple, and lastly turquoise, violet and red in varying amounts. Allow the colour fusions to develop and leave to dry.

At this point, you can add more layers of paint and salt to build up the colour and texture if you wish.

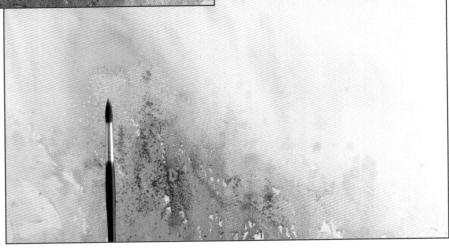

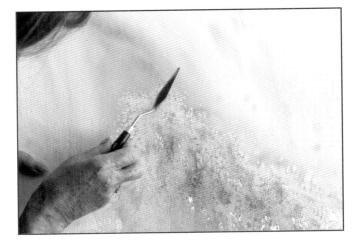

7 When dry, gently scrape off the salt using the edge of the painting knife. The salt disperses the pigment, and so leaves a pattern once it is removed. You are now ready to start work on the buildings.

8 Place a ruler or card vertically where you wish the lefthand side of the castle to be placed. Paint a broad orange stroke down the ruler. Bleed the colour away, taking it down and across the painting, then add in some red. Allow the paint to run down the painting – these runs will add pattern, texture and colour to the foreground. Both are translucent colours, so the pattern formed by the salt will still be visible underneath.

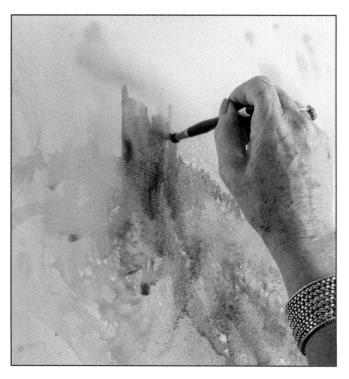

9 Very carefully lift the ruler or card to avoid disturbing the pigment. Holding the brush vertically, paint in the castle using a watery mix of red and orange. Take the brushstrokes downwards towards the lower right corner and paint in the detailing at the top of the castle with the tip of the brush. Extend the painting outwards from the main tower.

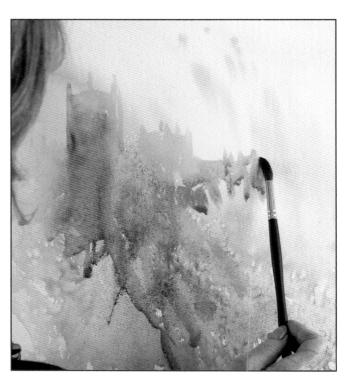

10 Extend the painting out to the right and the left, gradually fading out the buildings and leaving just a suggestion of them.

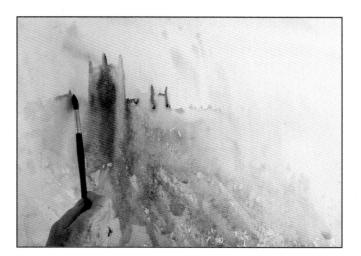

11 Splatter some turquoise paint into the foreground, then go in boldly with some darker colours to start to define the buildings, avoiding too much detail. Begin with heavily diluted violet, which can be a very strong pigment.

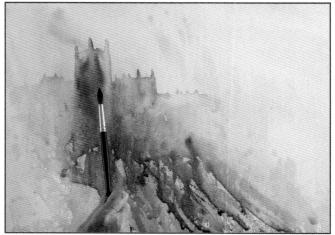

12 Start to inject more atmosphere into the foreground by splattering in turquoise, red then violet, and place a few directional brushstrokes moving away from the tower.

Tip

Give an illusion of movement through choice of techniques and directional lines.

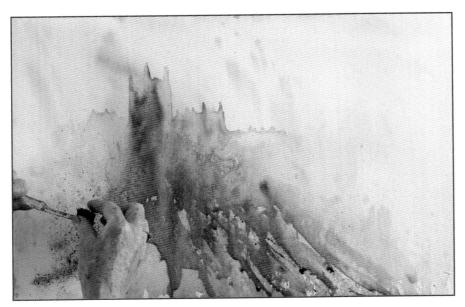

13 Splatter some water on to the top right of the painting to soften it and encourage the colour fusions to develop. Continue to build up the layers. Use the toothbrush to splatter more colour (red and purple) into the bottom left to add texture and interest, and to make it look different from the other corners of the painting. Splatter some turquoise over the main foreground too.

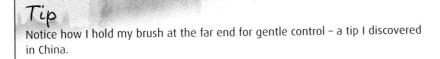

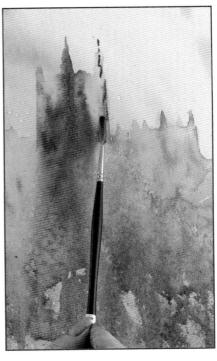

14 Start to focus in on the main tower. Add more detail using dark purple on the walls of the building using the side of the brush. Change to the rigger to add finer detail.

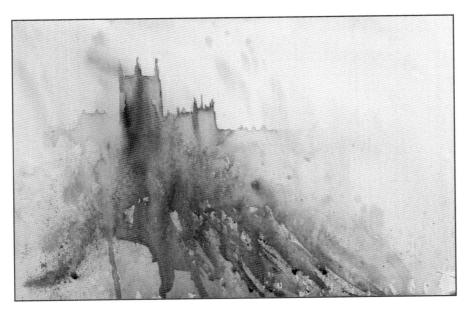

15 Strengthen the lower tower on the right, adding colour, then softening with a large, damp brush. This is a good point at which to stand back and assess your painting. Stop when you feel your painting is pleasing to the eye.

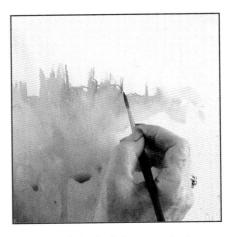

16 Extend the buildings out to the right using the size 10 brush, fading them into the sunlight. Add in a little purple, using a very watery mix. Change to the rigger to place a few hints of detail. Finally, splatter on some clean water to soften.

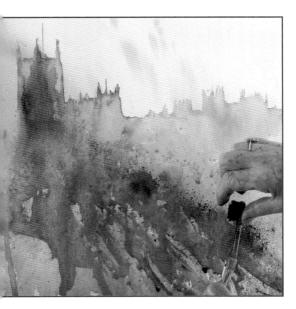

17 Paint in a staff on top of the main tower (use a ruler if you wish). Use purple to strengthen the tower still further and to suggest windows. Complete this stage by using a toothbrush to splatter on some colours from your palette. Finally, strengthen the colour in the lower right area of the painting with cadmium orange.

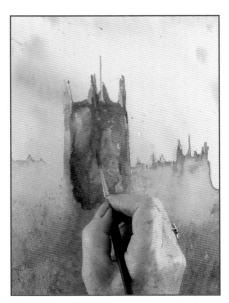

18 Decide if the main tower needs more detail. Using the rigger, put in the fourth, distant, turret. Gradually strengthen the outlines of the buildings. Soften some of the edges to create an illusion of misty morning sunlight.

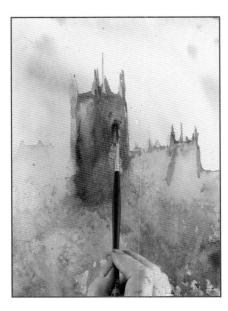

19 Strengthen the buildings to the right where you feel further detail is needed. You can add some red on the right-facing wall of the main tower. Bleed the colour down into the lower areas of the painting.

Tip

Add impact by using unusual colour additions and strong contrasts of bold and soft colour.

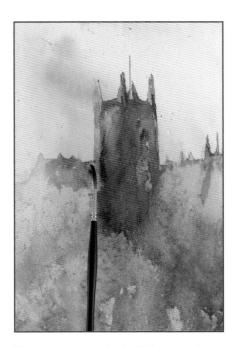

20 Strengthen the buildings on the left. Play with the colour contrasts, and soften the pigment as you work.

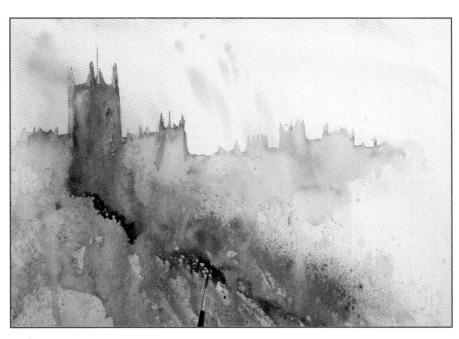

21 Taking the colour diagonally across the painting, look for the pattern created by the salt and accentuate it using alizarin crimson. Drop small amounts of perylene maroon into the wet alizarin crimson and allow it to fuse. This will create atmosphere within the painting.

22 Load your brush with clean water and make a small, directional stroke on the distant tower. Leave to dry. This will give an illusion of light hitting the façade of the building.

23 Add a suggestion of a line of trees to the right of the main tower. You can splatter the foreground with turquoise to complete the picture. Allow to dry before applying the final highlights.

24 Once the painting is completely dry, apply tiny amounts of white gouache using the rigger to create points of light where the sunlight is striking the scene – at the tops of the buildings, and on the stones at the bottom of the picture. Use your imagination to create interest.

TipDon't overwork the highlights – a few carefully placed highlights can have a dramatic effect.

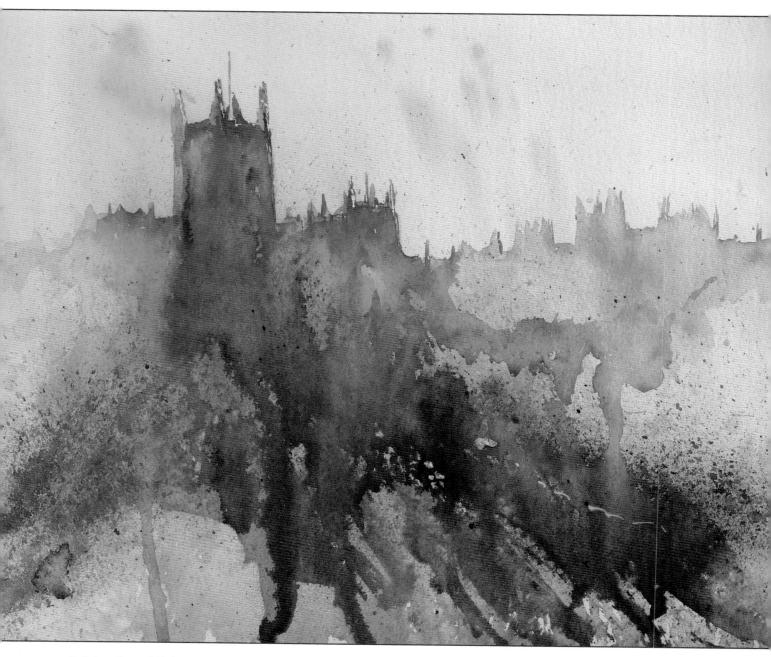

Celebration of Colour

56 x 38cm (22 x 15in)

Aim to create a painting that is full of intrigue, atmosphere, drama and excitement. Enjoy the experience of using glorious colour, and allow the viewer to use their imagination to bring the scene to life.

The simple church scene below was created in a similar way to *Celebration of Colour*. By selecting cool blue shades, I have gained a night scene. But by a simple change of colour selection this could be a stormy scene with rain instead of snow. The snow was created with a splattering of white gouache to give the painting a wonderful wintery effect. But the same scene painted with soft blue skies and a hint of yellow could quite easily make this a summer view.

How we use light in a composition can create drama and impact, and there are many ways to do this. Look at how different these two paintings are. The wonderful fact is that in art, there is no set way to paint a subject, and whichever approach you choose can be exciting. Colour and light are the keys to a successful result, whatever your style.

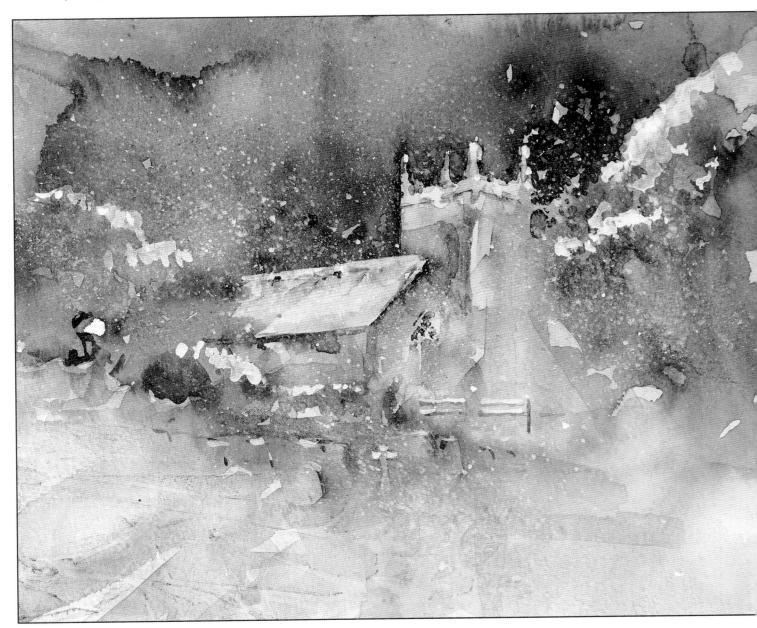

Silent Night 39 x 30cm (151/4 x 113/4in)

THE LAIRD

Painting portraits without the use of a preliminary sketch, using a photograph for reference, can lead to unique and interesting results. Try looking at your subject and simply placing colour where you see shapes, leaving white areas to hint at light hitting the face. Have fun experimenting and, initially, don't worry too much about a likeness.

Either follow the steps below, using the finished painting on page 122 for reference, or create a portrait from a photograph of your own, using the project to guide you through the process.

The technique you will be using is direct painting – this means you begin with the subject rather than a background wash. You will need to work continually, therefore it is vital to mix ample colour before you start.

1 To achieve a flesh tone, start by making a watery mix of yellow ochre and alizarin crimson on your palette. Try out your mix on a spare piece of paper to obtain the correct tone. Adjust the mix until you are happy with the result.

3 Introduce some alizarin crimson and play with the colour fusions to start adding definition to your painting. Drop in water at regular intervals to diffuse the pigment. Don't worry about drips — allow runs to develop.

YOU WILL NEED

- 300gsm (140lb) rough watercolour paper, 38 x 56cm (15 x 22in)
- Paintbrushes: size 8 squirrel pointed wash brush, and size 3 (fine rigger) and size 10 Kolinsky sable watercolour brushes
- · Palette
- Watercolour paints: yellow ochre, perylene maroon, quinacridone gold, cadmium orange, alizarin crimson, sap green, Winsor violet, French ultramarine, cobalt turquoise
- · Designer's white gouache

2 With the size 10 brush, hold the brush in the centre and start to paint the nose. Avoid definition at this stage. Using water, bleed the colour away from your starting point. As you work try to feel the shape of the face. Repeatedly refer to your chosen reference for guidance.

Tip

Don't be afraid to experiment with colour early on in a painting. Drop water in regularly to spread out the pigment and produce effects you can play with later.

4 Bring in some violet and start to define the eye area above the nose. Don't be afraid to drop in colour at this stage – mistakes can be corrected later. Use the brush in different directions to 'mould' the subject. Remember we are only aiming at placing colour at this stage, not detail.

5 Continue to move towards the forehead. Next move in a downwards direction towards the beard. Layer turquoise over violet here. To move colour towards the lower left corner, lay a track of water, then drop in alizarin crimson. Allow the pigment to flow along the water track.

6 Once the background washes are in place, you can start to add definition. Begin with the forehead. Place a water track with an upward curved brushstroke. Allow colour to merge into this track. Don't worry if you can't see the face yet – just work in colour sections.

7 Turning your attention to the nose, begin to add some darker shades – perylene maroon, then alizarin crimson. Soften with water and encourage watermarks. Lift out the highlight on the nose using a damp brush and a curved brushstroke.

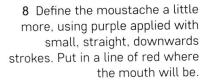

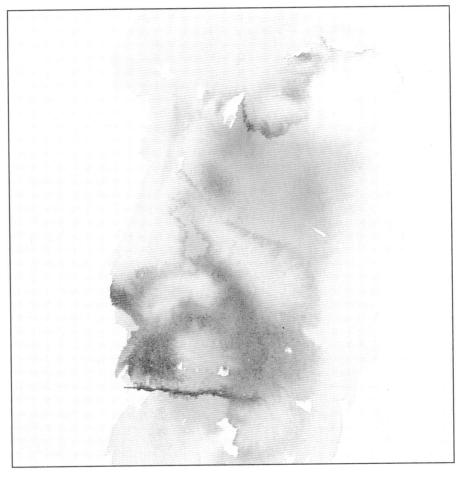

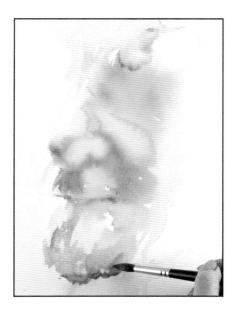

9 Working now on the beard, introduce violet, turquoise and then a little cadmium orange to warm and strengthen it. Start to add a little darker colour to define the lower edge.

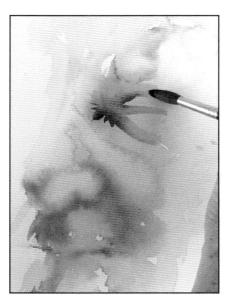

10 Position the eye starting with a touch of violet. Bleed the colour away from the inner corner of the eye to define the socket. Work gently with the brush and 'feel' when the subject is beginning to appear.

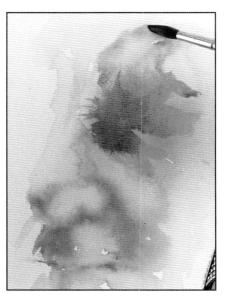

11 Continue dropping soft colour in where you feel darks are needed. Work towards the eyebrow and forehead. Start looking for distinctive features, though at this stage continue building up the layers of colour only; avoid detail.

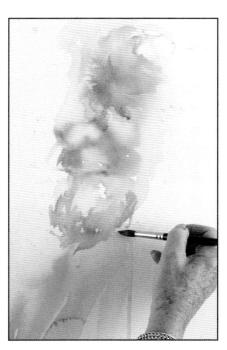

12 While the top part of the painting is drying, move down to the lower part of the face. Continue building up the colour in layers until the face starts to emerge. The more colour and pattern that develops, the more exciting the end result will be!

13 Introduce some cooler colours to the right of the head – this is where the sunlight is very strong, and shadows therefore more intense. Drop in turquoise followed by violet, which will create contrast. Lift out some colour to define the roundness of the cheek, and put in some stronger colour where you definitely know the cheek is.

14 Change to the small brush and find the eye using purple. Drop a little of the dark colour into the centre and pull it outwards to define the eye area. Add warmth to this area with a mixture of cadmium orange and alizarin crimson.

15 Mix some flesh colour for the area above the eye. While it is drying work on the upper cheek, bringing in some warm shades using curved brushstrokes.

define the ear and take the colour diagonally to the neck. Stop and look at your work frequently to see how your painting is developing.

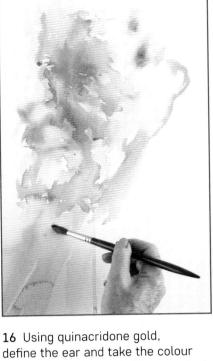

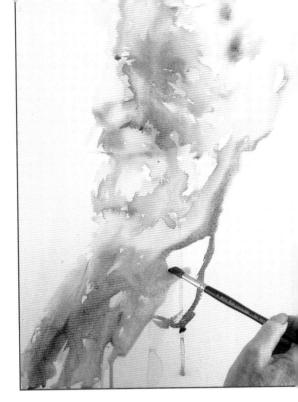

17 Apply red at the base of the neck to suggest clothing, and around the back of the head. Drop some violet pigment into the damp alizarin crimson and allow it to merge. This will define the Laird's red cloak. Dropping in water will encourage patterns to form.

18 Accentuate the highlight on the nose by building up the shadows underneath. Soften them slightly in places, then begin to strengthen the line of the mouth.

19 Continue building up the layers, gradually defining the main features to create character and capture the personality of your subject. Strengthen the turquoise in the lower part of the painting. This acts as a wonderful contrast with the warmer colours in your composition. Slightly darken the right-hand side of the beard using purple. Soften the colours as needed while you work. Accentuate the highlights by gently lifting out colour with a damp brush. You can strengthen the shadows under the nose at this stage if you wish.

1 up

Work with the translucent properties of the individual pigments to enjoy the full benefit of the watercolour technique described as 'layering of colour', which is used in this demonstration.

20 Put in the eye, aligning the inner corner with the edge of the nostril. Start by dropping in dark colour, then build up the detail. Work broadly around the eye area, then with clean water define the eye socket itself.

21 While the eye area is drying, work on other parts of the face that require further work – add some stronger colour to the top part of the face, drop in some alizarin crimson to warm up the cheek and darken the shadow under the nose.

22 Paint in the shadow area under the beard at the top of the neck using a mix of French ultramarine and sap green. Define the edge of the beard using an uneven line, then bleed the colour down. Drop a touch of the same colour under the nose to create harmony.

23 Turn the paper sideways, drop in some French ultramarine under the chin and let it run. Strengthen the shadow with a touch of violet.

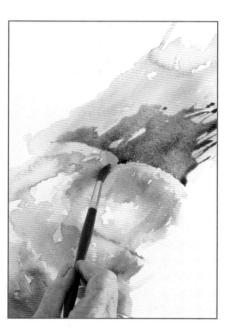

24 Turn the painting upside down and wet the side of the beard, allowing colour from the neck to bleed into it. This marries the two areas together, creating harmony.

25 Turn the painting back up the right way and splatter in some orange to add more drama and contrast.

26 Add some further refinements to the painting using the rigger – enhance beard detail using fine brushstrokes with purple pigment. Indicate the lower lip with a soft brushstroke. Place some turquoise in the top right of the picture to balance the colour in the lower left. Add tiny creases at the top of the nose. Allow the painting to dry.

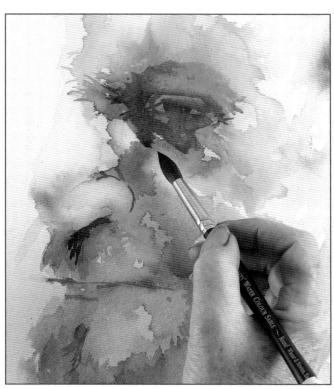

27 Start to add detail – define the curve of the nostril, and draw in the eye, beginning with the inner corner. Position it carefully, using your photograph or my finished painting for reference. Add colour to the eye socket, dampen and extend to the top of the cheek. Define the eyebrow and add some crease lines where needed.

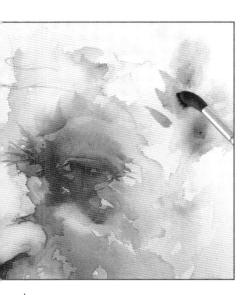

Add impact to your paintings by using unusual colour additions with strong contrasts of bold and soft colour.

28 Place a few brushmarks on the side of the head to add character. Use the rigger to place some subtle fine lines across the forehead.

29 Complete the painting by adding sharp highlights using white gouache. Start at the top and bring in a few hints of hair, then gently lay the brush on the moustache and add one or two subtle highlights there. Next, use a mix of small and large brushstrokes to place highlights within the beard, then dot some on the bridge of the nose, on the curve of the nostril and just under the eyebrow. Soften the highlights with a little water.

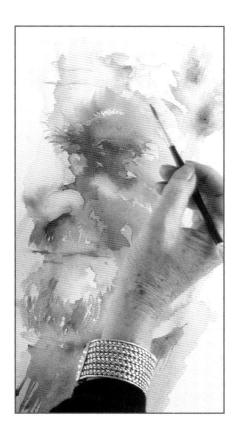

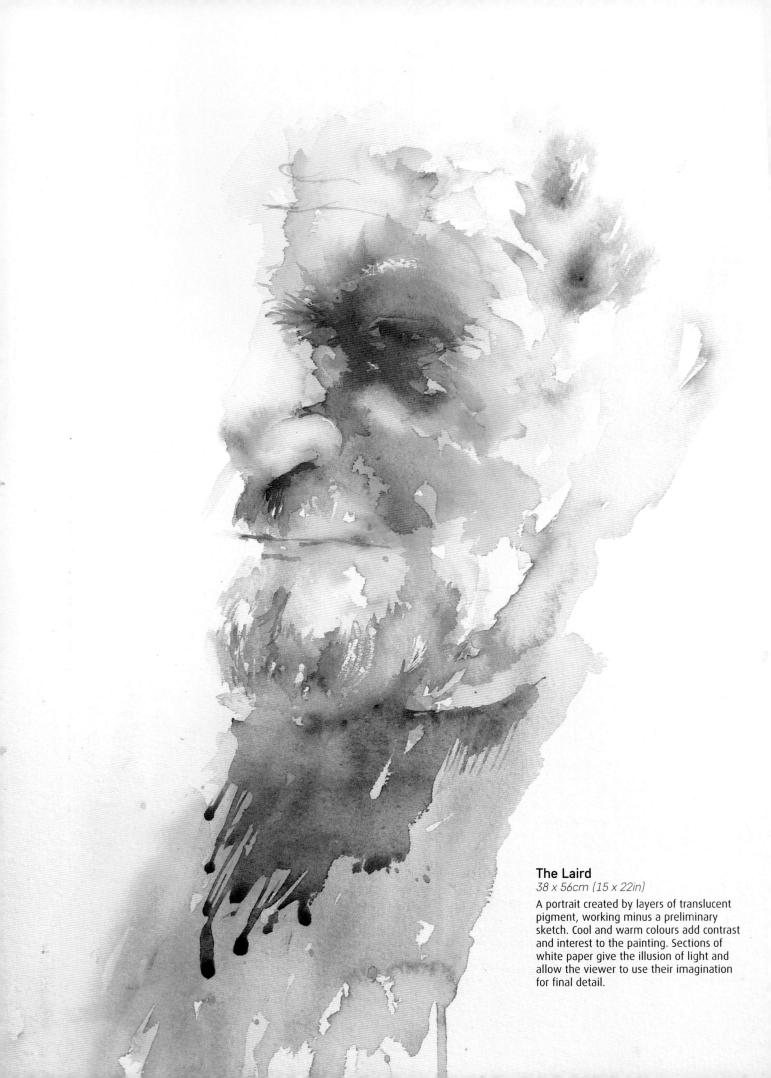

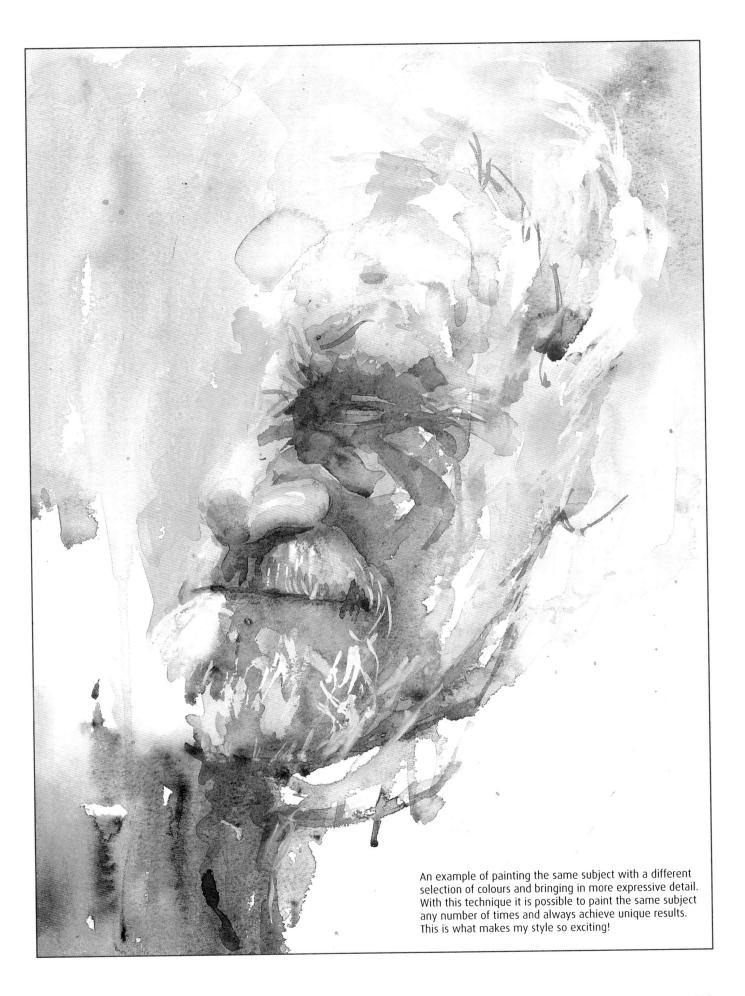

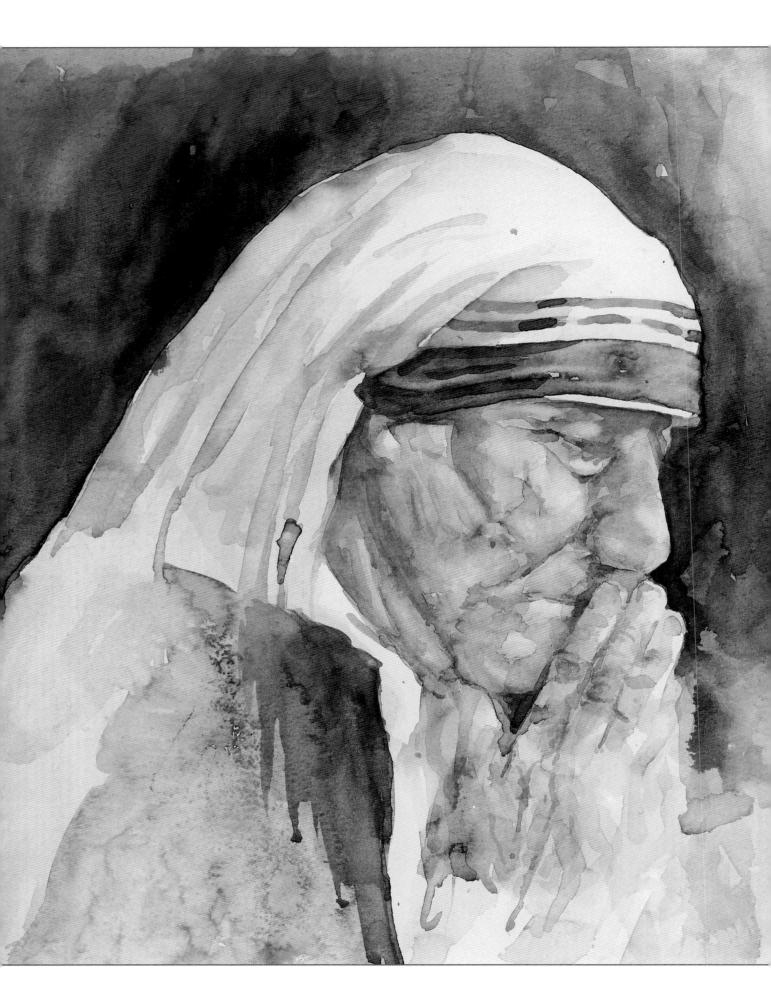

In Prayer

58 x 40cm (223/4 x 153/4in)

A combination of techniques is used in this painting. White is used for the head dress, and yellow creates warmth and light shining on the praying figure. Light in this composition gives a feeling of hope as well as sunlight. Salt used in the foreground gives a subtle textural effect for added interest, and breaks up the use of block colour in larger sections. The use of strong skin tones reflects the strength of the subject's character.

Colour alone can tell a story, especially when used well. Allowing our emotions and instincts to guide us as artists is a vital part of painting. Follow your heart, painting what you feel is right rather than what you have been told, read in a book or seen in an art class. At times we have to take a leap of faith and paint what is right for us and in a way that we believe in. This is how I created my personal style, and is the way you too can create a style of painting that is unique to you.

Whichever style you paint in, have the courage to experiment and believe in your own talent. One of the biggest obstacles many artists face is the lack of confidence in their own ability. I truly believe everyone can paint, they often just need the courage to keep going or to try something new.

Author's note

I spend hours every day painting in my studio or outside, and I enjoy each moment of it. If it is raining I can escape to sunnier days simply by choosing to work in bright yellow shades, and in doing so I can lift my mood and lighten my spirits.

Life as an artist is so magical because we are always looking for something new to paint. When I see light or shadows, I find them all the more fascinating because I know I can paint them, bringing what I see to life in a new composition. When colour and light become a part of our daily routine, the feeling is even more positive. Light and colour carry an energy that has a positive impact on all aspects of our lives, especially our well-being.

I have thoroughly enjoyed returning to my first book: Colour and Light in Watercolour. Reading the original chapters and adding to them has been a superb journey. It has shown me how I have grown as an artist since I first leapt into the unknown and became an author. I have learned so much by following my own footsteps in each original demonstration, and it has emphasised to me the importance of re-visiting regularly the techniques on which we, as artists, build our ability to paint. They are the stepping stones that allow us to continue our art journey, and constant reminders of where our painting methods may need improving.

I am ready and eager to paint all the more now, and I hope you will be too – happy painting!

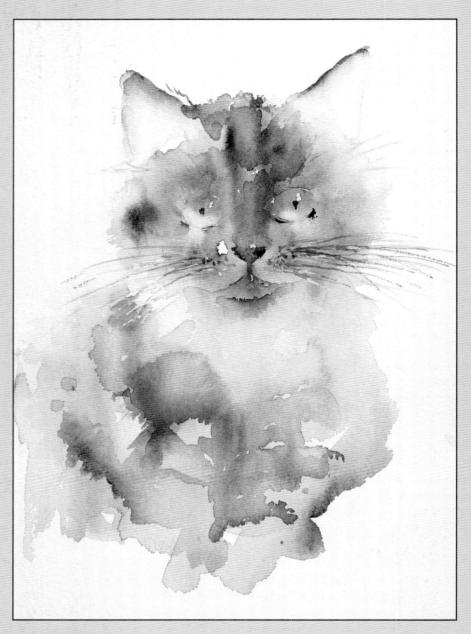

Shining Eyes 30 x 38cm (11¾ x 15in)

Havies

Index

Africa 4,52 anemone 69 animals 33, 86-87 architecture 46 see also buildings, castle Asia 12

boats 91-95 bleeding (colour) 13, 48, 49, 56, 58, 63, 99, 100, 101, 109, 112, 116, 118, 120 brushes 10, 12-13, 20-29 rigger 12, 20-21, 49, 63, 64, 82, 85, 91, 102, 111, 112, 113, 121 size 10 12, 22-23, 32, 62, 81, 86, 99, 108, 111, 116 size 12 12, 24-25 wash brush 12, 26-27, 98, 108 brushstrokes 13, 16, 59, 71, 84 see also brushwork directional brushstrokes 13, 16, 29, 40, 68, 71, 72, 77, 78, 94, 104, 106, 110, 113 brushwork 20-29 Brussels sprouts 36-37 buildings 46, 109-114 butterfly 49-51

castle 109-114 cherries 74 China 12, 15, 111 church 16, 115 cling film see plastic wrap cockerel 30, 68, 80-85 colour 30-37 colour flow 31, 32, 33, 34, 35, 36, 74, 80, 90, 98, 99, 117 colour fusions 11, 54, 55, 56, 66, 68, 69, 70, 98, 99, 104, 108, 109, 111, 112, 116 colour interaction 15, 31, 32, 34, 35, 36, 62, 66, 98 colour mixing 14, 30, 31, 34-35, colour selection 10, 36-37, 47, 59, 71, 78, 96, 98, 115 opaque colour 32, 33, 36 primary colours 31-32, 33, 34, 37, 60 secondary colours 34 translucent colour 36, 37, 109, 122 transparent colour 31, 33, 62-65, 83 composition 42, 60, 74-79, 90 contrasts 34, 36, 47, 52, 75, 97, 98, 102, 103, 112, 121, 122

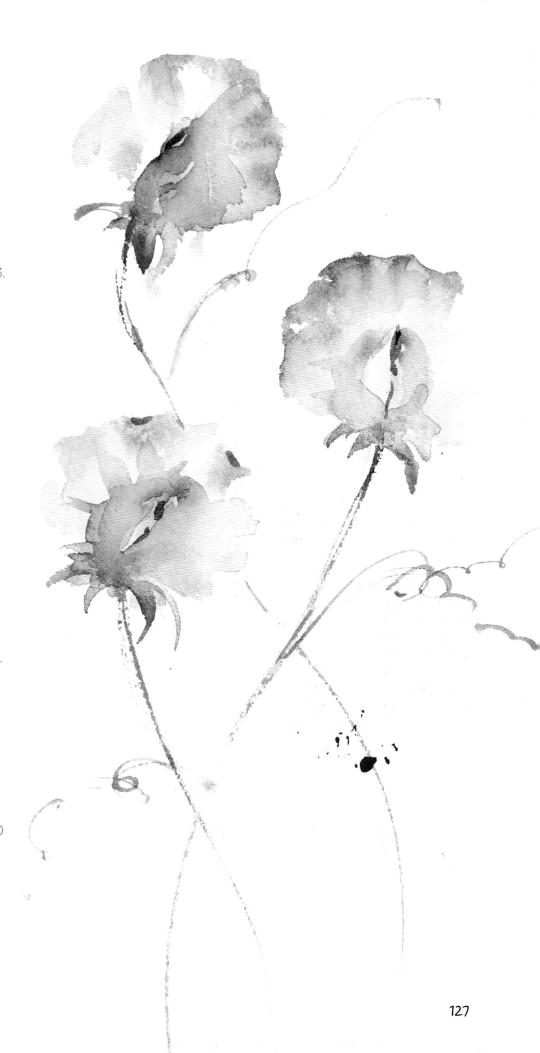

D

daffodils 26–27, 28–29, 59, 60, 61, 78 direct painting 116 dog 18, 75 Dubai 6, 7 duckling 39

Ε

easel 16 elephants 3, 52-53, 75 experimenting 11, 15, 19, 27, 34, 36, 37, 50, 51, 66, 70, 85, 93, 107, 116, 125 eyes 16, 48, 86-87, 89

_

figures 43, 48, 54–55, 77 see also portraits
finishing touches 16, 21, 65, 72
flowers 11, 14, 16, 19, 21, 22, 29, 33, 44, 46, 60, 61, 62–65, 78
focal point 16, 42, 52, 54, 75, 77, 78, 94, 96, 100
foliage 22–23, 27, 48, 63, 64
France 6
frog 38
fuchsia 56–57
fur 86–87

G

goats 42, 54 gondolier 43 gouache 16, 72, 89, 104, 113, 115, 121 granular pigment 11 granulation 11, 33 grape hyacinths 22–23

Н

hare 33, 86–87, 88–89 harmony 24, 26, 34, 36, 37, 50, 52, 63, 74, 84, 86, 92, 101, 102, 120 highlights 16, 40, 46, 48, 54, 57, 86, 104, 113, 121 honesty 72–73, 98–107 Hong Kong 6 horse racing 24–25

1

imagination 18-19

L

landscapes 14, 33, 58, 108–115 layers 26, 27, 51, 59, 62–65, 66, 72, 87, 93, 99–101, 111, 118–119 lifting 62, 63, 67, 81, 82 light 38–45 painting light 46–57 trapping light 24, 42, 54, 56, 63, 84–85, 102 lost and found edges 54, 55, 97

М

mouse 48 movement 24, 43, 49, 50, 54, 57, 60, 61, 69, 75, 78, 81, 96, 100, 104, 110 Murano 54-55

N

negative edge 63, 72 negative painting 58, 64, 72-73, 98

P

palette 10, 14
paper 10, 11
patience 19
photographs 42, 43, 116
pig 77
pigment see colour
pigment enemies 33
pigment friends 33, 35, 36
plastic wrap 27, 37, 44, 91–93
poppies 11, 66, 79
portraits 7, 14, 33, 76, 116–125
puppy 18, 71

R

rosehips 40, 71 roses 44, 62-65, 67 runs 68-69, 85, 108, 109, 116

S

sailing 90-95 salt 18, 19, 70-71, 80, 109, 112, 125 sea scene 90-95 sea turtle 35 seed heads 72, 98-107 see also honesty shade charts 32, 37 shadows 6, 8, 16, 39, 46, 51, 98, 118, 119, 120 shouts 33 sketchbook 11 skin tone 37, 116, 125 sky 6, 58, 90, 92-93 snow 16, 115 snowdrop 16, 17 splattering 16, 27, 29, 70, 87, 99, 100, 103, 104, 108, 109, 110, 111, 112, 113, 115, 120 still life 11, 33, 74 straight edges 18, 91, 109-110 sunflower 6,71 sunlight 6, 21, 23, 24, 26, 29, 38, 42, 43, 44, 46, 47, 48, 49, 51, 54, 60, 61, 63, 77, 91, 98, 112, 113, 125

Τ

texture 13, 16, 18, 19, 37, 70, 71, 77, 87, 109, 111, 125 tomatoes 36, 37 toothbrush 16, 70, 87, 111, 112 Turkey 42, 48

V Venice 6, 43, 47, 96–97

W

washes 12, 13, 19, 26, 38, 51, 58–59, 60, 93 water 10, 31, 32, 33 watercolour paints 15 water flow 11, 16, 23, 32, 33, 69 watermarks 9, 23, 32, 34, 66, 68–69, 82, 117 water tracks 32, 33, 98, 108, 117 wet in wet 62, 66, 68 whispers 14, 30, 33, 89, 108 wisteria 20–21

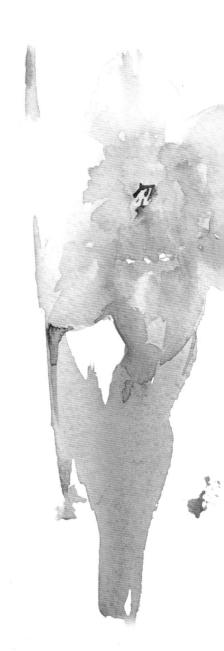